Acknowledgements

My best friend Sadie Sherain Mungal who has been at my side through eighteen plus years of ups and downs. She is an amazing, nice, kind hearted and thoughtful person, a real gem. I pray God will continue to richly bless her and her family and all her students. Thank you Sadie! :)

Special thanks to my wonderful friends Anthony (Tony) Ramlogan, Elizabeth Edwards, Mary Hospedales, and Gregory Hospedales for their spiritual support. They always provided an ear when I faced the many challenges throughout my writing journey. I am indeed blessed to have them in my life.

In loving memory of my dear friends Shantell Bubb and Shamilla (Shanti) Ragbir. You showed great kindness, courage, hope, faith, and love but sadly lost the battle to illness. Your support meant a lot to me. I pray your legacy may live on as an inspirational testimony in the lives of all those whom you have touched.

THE EDGE OF LEADERSHIP:

A Leader's Handbook
for Success

By
Brigette Tasha Hyacinth

Cover Design by Giovanni Misagrande
Book Design by Giovanni Misagrande

Legal Disclaimer
Information provided in this book is for informational purposes only and is not meant to substitute for the advice provided by your own physician or other medical professional. This book is not meant to be used, nor should it be used, to diagnose or treat any medical condition. Always consult with your physician or other qualified health care provider before embarking on a new treatment, diet or fitness program.

ISBN: 978-976-8260-46-8

Dedicaton

First and foremost I have to thank God for His mercies, grace, and loving kindness towards me and for blessing me with wisdom to complete this book.

This book is dedicated to my family. I love you all so much.

My heartfelt thanks to my dear mother, Marguerite Joseph, who has made huge sacrifices for me to be where I am today. She is the best mother ever. She is a beautiful, loving, diligent, intelligent, and godly woman, and I am so glad to have her as my mom.

A big thank you to Frank Hyacinth, my father, and to my brothers and sisters—Troy Hyacinth, Onica Hyacinth, Gavery Enrico Hyacinth—and to Alicia Hyacinth (sister-in-law), Che Nigel Hyacinth (deceased), Cheron Hyacinth, Ezra (Tricia) Ramlall, and Brent John for the huge support they provided.

Thank you to my nieces and nephew—Nicholas Hyacinth, Celeste Hyacinth, Jessie Ramlall, and Tinique Hyacinth. I am so proud of you all. May you continue to grow in grace and knowledge of our Lord and Saviour Jesus Christ. The world is yours for the taking. Once you put God first, nothing shall be impossible unto you. Think big, always look up, and never give up. May God richly bless you now and forevermore.

Contents

PART THREE: FOLLOWERSHIP

PART FOUR: LEADERSHIP LESSONS AND LIFE LESSONS

PART FIVE: PERSONAL DEVELOPMENT

PART SIX: LEADERSHIP PRACTICALITIES

Preface

Are you ready to take your leadership experience to the next level? Don't postpone any longer. **"The Edge of Leadership"** is focused on bridging the gap from where you are to where you need to be. It requires stepping outside your comfort zone and coming off well-trodden paths to begin a journey into the unknown. Growth occurs just beyond this edge, but it requires creativity, commitment, and risk taking.

This book will facilitate that safe journey and help you to think more broadly and strategically about the future, as it calls for introspection and self-awareness thus promoting personal development. In the end it will enhance your performance as a leader, and your team will thank you for the direction, motivation, and inspiration that you bring. With this foundation you will be much more successful in your leadership role.

Remember that leading at the edge is a lifetime process of discovery. **Let the journey begin!**

Part One

DEBATES
AND THEORIES

CHAPTER 1

Leadership vs. Management: What's the Difference?

When Frederick Taylor (1856-1915), began his studies in scientific management, he used a stopwatch to track productivity with the goal of improving performance. In Taylor's day, the manager's function was to take control to ensure productivity and profit. Frederick Taylor, father of scientific management, was an engineer; so was Henri Fayol, the early proponent of general principles of management.

Henri Fayol (1841-1925), was a key figure in the turn-of-the-century classical school of management theory. Fayol provided one of the most influential modern concepts of his time. He pioneered definitions of control for management science. He is founder of the five functions of management:

- planning
- organizing
- commanding
- coordinating activities
- controlling performance

Most of these activities are very task-oriented, rather than people-oriented. This is very like Taylor and Scientific Management.

According to Fayol, "To manage is to forecast and plan, to organize, to command, to coordinate and to control. To forecast and plan means examining the future and drawing up the plan of action. To organize means to build up the dual structure, material and human, of the undertaking. To command means maintaining activity amongst the personnel. To coordinate means bonding together, unifying and harmonizing all activity and effort. To control means seeing that everything occurs in

conformity with established rule and expressed command." (Henri Fayol, Administration Industrielle et Generale, 1916).

LEADERSHIP VS. MANAGEMENT: WHAT'S THE DIFFERENCE?

The terms *management* and *leadership* are often used interchangeably. In fact, many people view them as basically the same, but they are different. One key distinction between management and leadership is that we manage things and lead people.

Leadership requires the ability to influence a group toward the achievement of goals. Leadership is largely situational. Leadership seems to emerge when a situation occurs that demands someone to take the helm.

Management requires the use of authority inherent in designated formal rank to obtain compliance from organizational members. It is the set of processes that keep an organization functioning.

Management is a science which can be learnt and taught; leadership is an art. Management is a function, while leadership is a relationship. Leadership is about getting people to understand and believe in your vision and to work with them to achieve your goals.

Subject	Leadership	Management
Decision Making	**Participative** Intuitive (EQ)	**Directive** Analytical (IQ)
Approach	**Vision** Long Term Strategic	**Administration** Short Term Tactical
Style	**Transformational** - Charismatic Empowering & Mentoring Followers	**Transactional** - Autocratic Instructing & Monitoring Subordinates
Power	**Influence** Persuasion Inspiration	**Formal Authority** Position Policies
Focus	**People Oriented** Values & Principles Culture	**Task Oriented** Procedures Structure
Risk Tolerance	**Risk Seeking** Innovation Flexibility Embraces Change	**Risk Averse** Standardization Stability Maintains the Status Quo
Motivation	**Achievement** Attainment of Vision Heart - Passion	**Compensation** Monetary Rewards Head - Intellectual

The two concepts are indeed quite distinct, and understanding differences between leadership and management ensures that you can see where to improve and not assume you are simply good at both. By contrasting them and understanding their differences, we can better balance and develop these essential roles.

DECISION MAKING: PARTICIPATIVE VS. DIRECTIVE

Leaders say "Follow me into the battle." Managers say "Now you go ahead as discussed and planned."

Managers delegate and assign duties, while leaders actively participate. Leaders show how it is done and back up their team with the support to help them succeed. They thrive on engagement. Managers explain how to do something. Leaders lead by example through their own actions. Managers use "me", Leaders use "we." Leadership is a team game, and true leaders make great team players because of their ability to understand and connect with people around them.

True leaders lead from the front rather than push from behind. They inspire their team through negotiations, discussions and welcome feedback. Unlike managers, they are intuitive rather than analytical. Managers are required to have experience and formal academic qualifications, but for leaders this may not necessarily be a prerequisite.

Great leaders possess a high Emotional Intelligence Quotient (EQ). They are good at assessing others' emotions and using this to facilitate thinking and creativity, whereas managers may rely mainly on analytical reasoning (Intelligence Quotient, or IQ) to solve problems. It's been extensively documented that EQ skills are more of an indicator of success than IQ skills in today's business environment.

Managers often depend on complete data reports in decision making as they are required to justify their actions. Great leaders have the ability to make good decisions without securing all the information needed. They know how to leverage information and resources to achieve their goals.

APPROACH: VISION VS. ADMINISTRATION

Leaders are focused on the mission and are interested in the big picture. Managers are accountable for the present.

Leaders are accountable for the future. Managers organize and plan to meet the year's objectives. Leaders create a vision of the years down the road that will change the course of history.

Management centres around the actions of planning, organizing, and efficiency; leadership is the abstract creation of vision and strategy. The manager asks how and when; the leader asks what and why. Leadership defines what the future should look like, aligns people with that vision, and inspires them to make it happen despite the obstacles.

Managers place emphasis on details. Great leaders are strategic thinkers who have the ability to translate their vision into an actionable strategy to ensure its success. They are solution focused, while managers are problem focused.

Leaders focus on where they are going—the outcome. Managers focus on how best to get there—the process to reach the outcome. Leaders are architects and managers are the construction experts.

STYLE: TRANSFORMATIONAL VS. TRANSACTIONAL

The leader is chosen by his team, while the manager in most cases chooses his team. Managers rely on control; leaders rely on trust.

Leaders trust teams to deliver, and their teams trust in their leadership. Leaders focus on team building. They coach individuals to grow and expand. Dictating through an autocratic management style will not win the hearts and minds of individuals, so leadership plays an important role in leading and motivating teams to achieve those new limits.

Leaders build people through training, coaching, mentoring, and rewarding. They recognize that everyone is motivated differently. Managers, on the other hand, believe people will be motivated if you pay them enough. Leaders understand that pay is a satisfier but not the only motivator.

Leaders openly praise and reward teams for good work, while managers prefer to take the credit for themselves. Leaders are good at making you feel you are important. Bosses make you feel they are important. Managers try to be heroes. Leaders make heroes of everyone around them. They celebrate with their team. Leaders know how to manage a myriad of intense personalities and get them going in the same direction even if they don't like each other.

Managers direct groups. Leaders create teams. Leaders surround themselves with talented individuals and are not intimidated by their skills or knowledge base. They build strong relationships and ensure their team is well balanced. They embrace succession planning: developing leaders rather than just more followers.

POWER: INFLUENCE VS. FORMAL AUTHORITY

Leaders command respect. Managers demand it. The term manager means you are a steward, a custodian of someone else's belonging. Managers are the instruments of corporate

policy, whereas leaders are selling a vision that requires others' buy-in.

Managers in many entities represent an authority system or position. They excel in figuring out the best way to control their team to complete tasks. Leaders inspire people to do the tasks. They inspire their teams to cross their limits. A manager acts within the confines of his job description. Managers are given tasks and instructions to follow from above and relay them down, distributing them to get the job done.

Leaders make their own decisions. Great leaders possess great interpersonal and communication skills. They are good listeners. They keep their team informed of all aspects of the journey. They tend to be people-centric and understand the concept of servant leadership: customers and team.

They lead by serving as opposed to intimidating. They thrive on finesse and subtlety to get the job done. Managers have the authority to tell others what to do. Leadership is about setting a good example and encouraging others to follow. People follow you because they want to.

FOCUS: PEOPLE ORIENTED VS. TASK ORIENTED

Managers get results in spite of the people. Leaders get results because of the people.

As one employee stated, "Managers only get my best because of the expectations I have set for myself, not for them."

Managers sometimes set targets that are unattainable for their team. Leaders aim at making people reach their true potential.

Management is monitoring key performance indicators (KPI), numbers, and spreadsheets. A manager is interested in the bottom line. A leader is interested in followers—the people who will deliver the process that leads to the bottom line. Management is basically concerned with arranging the processes, people, and materials. Management creates an outline to follow and focuses on process improvement and operational excellence. It is a structured function with a set of processes required to manage the business activities of day-to-day operations. Management administrates to ensure things get done, whereas leadership inspires that implementation.

Managers emphasize systems more than people and can be cut-and-dried in their work relationships. They easily see milestones and deadlines. Leaders invest their time in developing people and getting to know the team. They think about people and their talent as if they were investment opportunities. Great leaders often place great importance on ethical values. They choose to do what is right even when it is difficult.

"Management is efficiency in climbing the ladder of success; leadership determines whether the ladder is leaning against the right wall."—Stephen R. Covey

RISK TOLERANCE: RISK SEEKING VS. RISK AVERSE

Leadership is about change. Leaders innovate, develop, and invent.

Managers maintain conformance to existing standards. They "go by the book."

Leaders set new directions because their focus is on creating new paths. They take people to places they have never been. Managers keep them in place.

Leaders colour outside the lines while managers colour inside the lines. Leaders seek to ensure the business model is in alignment with the ever-changing environment: consumer tastes, technology, social attitudes, and other considerations. They are proactive rather that reactive. They anticipate and lead change.

Managers are trapped in the confines of the box within the system. If managers overstep their bounds and attempt to revolt against the existing culture, they may soon find themselves out of a job. This was sadly the fate of my esteemed manager Joseph who received the boot (refer to Chapter 20: The Memorable Leader). Leaders are committed to both personal and professional success. They are continuous learners who are always looking for better methods, different approaches, and increased velocity. Leaders challenge the conventional routines and systems and bring out the best in people. They live by their own principles and convince others to do the same.

Some of the best managers are very good at studying best practices—ways to build a "better mouse trap" to improve performance and efficiency.

Effective leaders are creative in their approach, developing new ideas to resolve current issues and implementing them effectively to prevent future recurrences.

"Management is doing things right; leadership is doing the right things." —Peter Drucker

MOTIVATION: ACHIEVEMENT VS. COMPENSATION

Being a manager is a job. Managers implement the practices of the organization. Being a leader is a role. Leaders guide and inspire. Their fulfilment comes in bringing about positive change. A good leader puts the interest of their followers before their own and measure success by whether their followers are better off.

Leaders help organizations and people to grow, while a manager's greatest accomplishment comes from making work processes more effective. Leadership breeds loyalty, dedication, and accountability. Leaders inspire, motivate, and influence their teams and assist them in reaching their goals and achieving their highest possible performance.

Leaders put the team before their personal aspirations. Leaders are passionate about their causes and are willing to risk all for the fruition of the same. Managers are paid to get things done.

Managers are forgotten, but leaders live on in the hearts and minds of their followers long after they have gone.

TAKING THE NEXT STEP TOWARDS LEADERSHIP

It's possible for a manager to become a leader. Sometimes it just takes being aware of what they need to do to fulfil their responsibilities as a leader. Managers can become effective leaders by adopting the following.

- ⮑ **Vision:** Focusing on the long term, the big picture. Leadership is about reducing fear and increasing hope.

- ⮑ **Integrity:** Good leaders are honest, fair, and trustworthy.

- ⮑ **Team Building:** Creating a climate that encourages and values the contributions of team members. Show that you genuinely care.

- ⮑ **Communication:** Good communication skills are essential for effective leadership. Always keep your team informed. Be open and honest. Listen with the intention of understanding and welcome feedback.

- ⮑ **Inspiration:** Inspiring and motivating others to be all they can be.

- ⮑ **Continuous Learning:** Successful leaders strive for ongoing personal development. Developing leadership skills is a lifetime project.

- ⮑ **Humility:** Don't think you are too high up the *hierarchical* ladder to get involved. Aim to serve rather than be served (servant leadership).

- ⮑ **Relationship Building:** Spend time with and get to know your team. The most effective leaders build their relationships through trust.

- ⮑ **Risk Taking:** Don't be afraid to do things differently, to develop new pathways. Welcome new ideas and embrace creativity.

- ⮑ **Reward and Recognition:** Acknowledging and appreciating each team member's contribution and giving meaningful rewards is essential to keeping the team happy.

ARE ALL LEADERS MANAGERS?

Many people believe that being a good leader automatically means you're a good manager and vice versa. Sometimes great leaders aren't able to effectively manage people because they think too macro and not enough micro.

Don't assume that someone who has a proven track record in leadership or management automatically possesses both skills. Leaders don't always make good managers. It is a rare individual who excels in both managing and leading. Both, however, are critical to success in a high-growth business.

The world is littered with companies that had visionary and inspirational leadership but failed to execute due to a lack of competent management. For example, entrepreneurial start-up companies often have strong vision, passion, and energy (leadership) and may also have good technological or technical skills. But a lack of systems and processes (management) leads to an organizational decline. A lot of entrepreneurs are leaders and not managers.

Naturally, leadership is ahead of management. A well-balanced organization has leadership at its base. Many of the world's greatest leaders did not function with a formal title or within the confines of an established organization. According to Colin Powell, "Leadership is an art of accomplishing more than the science of management says is possible."

In this time of economic uncertainty, technological advancement coupled with the increasingly complex and volatile business environment, the need to demonstrate both leadership and

management in perfect situational correlations has never been more critical for success. The two go hand-in-hand, and there has never been a time in history when individuals who possess a blend of both leadership and management skills are more in demand.

The great need for charisma and inspiration is a must, but equally systems must be monitored and controlled to ensure tasks and road maps are created to operationalize the vision, which is normally achieved through the management function. Without efficient management skills the direction set by a leader risks being unsustainable.

In building our businesses, we need to harness our passion and creative spirit with disciplined processes. For an organization to achieve strong results, both leadership and management need to be present. With good management and poor leadership the team will lack the inspiration and passion to pursue goals. How an organization strikes balance between management and leadership depends on the circumstances, the people, and the environment in which it operates. Being able to blend these two styles is truly a unique skill set. Keep in mind there is an abundance of managers in the world but few embody the characteristics of leaders.

Therefore, both management and leadership are needed just as the right and left wing are both essential to an airplane's flight. Although there will be high turbulence, passenger disruptions, and the need to alternate between altitudes, both leadership and management are required to steer the organization to a successful landing, thereby, reaching its projected destination in an effective and efficient manner.

CHAPTER 2

Are Leaders Born or Made?

Which came first, the chicken or the egg? To be or not to be? Nature versus nurture? Can we finally put age-old arguments like these to rest and come to a conclusion?

Leadership means exercising influence over others on behalf of the leader's purposes, aims, or goals.

LEADERS ARE BORN NOT MADE.

Great Man theory and Trait theories believe that people inherit certain qualities and traits that make them better suited to leadership.

"To suggest that leaders do not enter the world with extraordinary endowment is to imply that people enter the world with equal abilities, with equal talents." —Thomas Carlyle (1840).

There are certain inborn characteristics that predispose people to being and becoming leaders. There is a significant difference between learning a skill and mastering one, in the same way that others are born with amazing musical gifts or athletic talents. They excel naturally in these areas, while others are like fish out of water and may struggle to get to the same point.

Natural born leaders are different from those that are made—artificial leaders. All remarkable leaders have great history behind them. They were leaders from the onset of their journey. If leaders were solely born, what would be the point of the rest of us studying leadership or management? Birth is a natural process and the notion to associate leadership with it is arguable.

LEADERS ARE MADE NOT BORN

Behavioural theories believe that people can become leaders through the process of teaching, learning, and observing. Leadership is a set of skills that can be learned over time

through training, perception, practice, and experience. Leadership learning is a lifetime activity. Good leaders seek out development opportunities that will help them learn new skills. The military embraces this doctrine, which is evident through its leadership training programme.

However, can completing a programme on management and leadership make someone a leader?

Can charisma, influence, integrity, and the ability to inspire be taught?

Will a certificate and a few letters after one's name make a person a leader?

Soft skills can be explained, but not implanted. The ability to share your vision takes more than a sophisticated PowerPoint presentation and some crisp words on a bunch of 4x6 cards. Anyone with the basics can learn leadership, but a lot of leadership cannot be taught. Some do well, while others find themselves poorly equipped, rendering mediocre results.

THE VERDICT:

Leadership is an art rather than a science. It is a set of innate traits, refined and perfected over time with education, training, and experience. There is also an aspect of being in the *right place at the right time*. You may be a leader, but what also matters is whether or not you are in the position within which your talents can shine forth.

The discussion about leadership also needs to identify the *location as well as the environment.* Are we speaking about these major performers (born or made) in a small organization, in an industry, in a society, in a country, or in the world?

If the fear of leading overrides the willingness to take on the responsibilities, then one is a follower. Not everyone can be a leader, just like not everyone can become a good actor. Some people will never have that aspect in them, while others have the latent ability and thus can be taught how to lead. *All the books, classes, education, and training in the world cannot turn a follower into a leader.*

To be a leader in a structured environment, one needs some formal training. Most people can learn to manage well, start a business, or lead a project team since good management is based on rules—rules that can be learned and mastered.

LEADERSHIP IS OFTEN A CHOICE

A leader is a person who comes forward to take the challenge. If a leader rises up from the multitude, that person was most likely already a leader. Some people have the best training, nurturing, and opportunities, but would rather hide in the crowd and be unwilling participants ... not leaders.

LEADERSHIP STYLES VARY

Styles vary depending on maturity, followers, and situations:

In the GLOBE (Global Leadership and Organizational Behavior Effectiveness) research study conducted in 2004 across sixty countries, researchers were able to identify **22** attributes that are universally regarded as contributing to outstanding leadership. These include the following traits: "trustworthy, just, honest, foresight, plans ahead, encouraging, positive, dynamic, motive arouser, confidence builder, motivational, decisive, excellence-oriented, dependable, intelligent, effective bargainer, win-win problem solver, administratively skilled, communicative, informed, coordinator and team builder."

These attributes are a combination of personality, character, skill, communicative ability, and emotional intelligence. Therefore a leader is born, developed, skilled in communications, and cultivated through life experiences. The best theory offered by research is that leadership is about one-third born and two-thirds made. It all depends on how one defines leadership. It is possible for either. Depending on how you define leadership, everyone can lead and be a leader. Perhaps we should seek to quantify leaders rather than qualify them.

Remarkable leaders include Nelson Mandela, Mahatma Gandhi, Martin Luther King Jr., and Aung San Suu Kyi. These selfless individuals sought neither wealth nor fame, loved justice, were passionate about people, and worked for the greater good of others.

In studying leadership, the theories can be overwhelming. It is evident you cannot really support one side and negate the other. Although there are thousands of books and decades' worth of well-documented studies, the debate can go on forever without converging to form a logical conclusion. That's why I would like to share a true story.

MY STORY:

From the time I was little, all the elderly villagers (who have long passed) would tell my mother "This child is different." I was always focused and driven and had a passion and desire to lead. I was not born with a golden spoon, a silver spoon, or any other spoon in my mouth. Things were extremely tough growing up. I am actually the only one of my relatives to have attained undergraduate education. My mother is now taking literacy classes, and I am so proud of her.

I remember two moments from my early childhood quite vividly. The first was having a conversation with my mother when I was around five and telling her I wanted to go to school. But at that time she could not afford to send me. The second was playing marbles when I was around seven or eight with a neighbour and hearing his mother whisper to him, "Why are you playing with Brigette? She is so serious." I was always persistent and competitive.

While most of the people in my community accepted being victims of circumstances and floated downstream, I instinctively paddled upstream against the prevailing currents. Was it hard? Was it lonely? Did I get depressed? Yes, to all of those, yet I was compelled to keep moving forward. Thank God!

I believe there must be some deep rooted spark if not an intense fire within. Are leaders born or made? Neither. Leaders are both born and made.

The Pareto principle named after economist Vilfredo Pareto, also known as the 80—20 rule states that for many events, roughly 80% of the effects come from 20% of the causes. It observes that most things have an unequal distribution. According to this principle, leaders are 80 percent made and 20 percent born. However, studies conducted out of the University of Illinois, support past research that leadership is 30 percent genetic and 70 percent learned. As to how the percentage is precisely divided between both born and made, I believe this may be subject to individual circumstances, since no two leaders will have the exact ratios listed above.

CHAPTER 3

A Leader's Clothes: Leadership Styles

As a child growing up, I remember reading Hans Christian Andersen's *The Emperor's New Clothes*, which made a lasting impression on me, to this very day. The art of introspection

is critical to a leader since leaders may be surrounded by courtiers who appease the emperor and praise the non-existent clothes. Good leadership is being open to honest feedback and responding to it positively and constructively.

What do your "clothes "say about you? I have met some leaders who have boasted they have been wearing the same clothes for a number of years. When was the last time you cleaned out your closet to rid yourself of clothes that no longer fit the time or environment?

When developing leadership skills, one must soon confront an important practical question: *What leadership styles work best for the organization and for me?* **Theoretical examinations of successful, world-renowned leaders have revealed leadership style as an indicator of organizational success** (Adeyemi-Bello, 2001).

Psychologists have developed useful frameworks that describe the main ways to lead. When you understand these frameworks, you can develop your own approach to leadership, and become a more effective leader.

Here are the Eleven types of "clothes" I have observed some leaders wear throughout their terms.

ELEVEN TYPES OF "CLOTHES"

1 **Pajamas: Laissez-faire / Delegative** Leadership Style

The laissez-faire leader is extremely passive and inactive (Northouse, 2006). This is a "hands off" style of leadership. The leader gives the power of decision making to the group, along

with the materials needed to make that decision. Frequent absence and lack of involvement is characteristic of this style. These leaders give their team members a lot of freedom in how they do their work. It's surprising how some leaders don't have a clear view of what is happening around them or how their actions are affecting employees and the organization. In this aspect, you could say they are sleeping. Researchers have found that this is generally the leadership style that leads to the lowest productivity among group members. However, laissez-faire leadership can be effective in situations where group members are highly skilled and capable of working on their own.

2 Jogging Suit: Coaching Leadership Style

Used by active, highly engaged, and visible leaders, this style involves a great deal of hands-on involvement in an employee's work process. These leaders are totally focused on organizing, supporting, and developing the people on their teams. This is can be referred to as healthy leadership. The coaching leader directs, guides and provides inspiration to help motivate their team. They create a positive workplace environment; followers know exactly what's expected of them, and they understand the strategy of the company. The coaching leader develops people for the future. Coaching increases goal attainment, enhances resilience, and increases workplace well-being (Grant, Curtayne, and Burton, 2009). This type of leader models excellence and self-direction.

3 Heavy Work Coverall: Autocratic / Authoritative Leadership Style

Autocratic leadership is an extreme form of transactional leadership, where leaders have a lot of power over their

people. Autocratic leaders typically make choices based on their own ideas and judgements and rarely accept advice from followers. Little feedback is sought from team members. This style can be appropriate when decisions have to be made quickly or when team agreement isn't necessary for a successful outcome. *Autocratic leadership* style was regarded as the most prominent leadership style one hundred years ago and is still suited for Theory X type of workers (refer to chapter 12 where Theory X type of workers is discussed in more detail). Autocratic leadership is often best used in crises, when decisions must be made quickly. The benefit of autocratic leadership is that it's incredibly efficient but may not be very effective as this style can be demoralizing, and can lead to high levels of absenteeism and staff turnover.

4 Business Suit: Bureaucratic Leadership Style

This style emphasizes procedures and historical methods regardless of their usefulness in the changing environment. The bureaucratic leader follows a "by the book" management philosophy. This style was first developed by Max Weber in 1947. They see themselves on a higher level and superimpose the hierarchy. They get things done within the umbrella of the status quo and may intimidate their staff. Following rules, policies and procedures meticulously is what the *bureaucratic leader* lives for. Bureaucratic leadership is useful in organizations where there are serious risks and compliance is a must, such as what you would expect at a nuclear power plant, a police station, a bank or industrial or construction sites. Where bureaucratic leadership can fail is in organizations that must adapt to change or take risks on a regular basis. This style can stifle creativity, innovation and flexibility in organizations, thus preventing the company from achieving its goals.

5 Lab Coat: **Strategic** Leadership Style

Strategic leadership is a management model that trains and encourages employees to best prepare the company for the future. Strategic leaders are always looking ahead and analyzing the present in terms of preparation for what may be ahead for the business. A strategic leader surveys the current marketplace for growth opportunities, once they spot where the company needs to go, they set goals to position the company to achieve that growth. They grasp the entire situation and bring new thinking into play. Those with this style are good listeners, risk takers and problem solvers. Failures don't impede progress. Awareness is a big part of strategic leadership style.

This leadership style is dynamic by nature as strategic leaders are adaptable and growth-oriented. Innovation and change are at the core of their being. This type of style tends to be seen in organizations that must innovate to stay in the game.

6 **Rain Coat: The Democratic / Participative** Leadership Style

A Participative leader, rather than taking autocratic decisions, seeks to involve other people in the process, but retains the final decision making authority. Participative leadership involves the entire team. This is a leadership style in which the leader works closely with team members, focusing on building relationships and rapport. These leaders are not afraid to get their hands dirty and value the input of team members. They don't run from the storm. They take the blame for their team when things go wrong rather than looking for a scapegoat the minute a crisis occurs. Leadership is, and always has been, about character. True character is revealed when a leader has

something significant to lose. Team members tend to have high job satisfaction and are productive because they're more involved in decisions. Participative leadership doesn't always work in situations where the team members have conflicting views or can't agree. This can hinder speed or efficiency in the decision making process. This may also not be suitable in situations where the leader alone is privy to classified information that can't be shared with the team in order to make a decision.

"Get out in front where you can see and be seen. That way, not only will you know what's going on, but those who follow will know what's going on." —Dr. William Cohen

7 Apron: Servant Leadership Style

The phrase "**servant leadership**" was coined by Robert K. Greenleaf in The **Servant** as **Leader**, an essay that he first published in 1970. Leaders serve their people. A servant leader is someone who leads simply by meeting the needs of the team. They focus on and invest time in people. They are genuine, have high integrity and lead with generosity. They lead by example. Servant leadership gives emphasis to the needs of the follower over the self- interests of the leader (Laub, 1999). Grounded in teamwork and egalitarianism, the servant leader involves followers in decision making. Being genuine and humble are some of the qualities they possess. They prefer to give others the spotlight. They are not afraid to say they don't know. They are honest with employees about what is going on. This style is ill-suited in situations where there is employee opposition. "The servant-leader is servant first... Becoming a servant-leader begins with the natural feeling that one wants to serve, to serve first... That person is

sharply different from one who is leader first... The difference manifests itself in the care taken by the servant first to make sure that other people's highest priority needs are being served." —Robert K. Greenleaf

8 Party Dress: **Machiavellian** Leadership Style

Machiavellianism is described as "the employment of cunning and duplicity in statecraft or general conduct," it of course gets its derivation from the Italian diplomat, writer and philosopher Niccolo Machiavelli. It is self-seeking. Such leaders don't usually reveal the entire and/or real reason they're doing something unless it's somehow advantageous to them. They don't give recognition where it is due but take the credit for themselves. They are narcissistic and boastful. They love power. They consider their personal image of utmost importance. They often employ unethical methods to achieve noteworthy results (the ends justify the means). They focus on short term personal gains at the expense of team success. These leaders with their cut throat tactics create an atmosphere of distrust and low morale.

9 Casual Attire: **Charismatic** Leadership Style

The Charismatic Leader gathers followers through their personality and charm. They are well liked by their team and continuously praise team members for their efforts. They create a positive culture that leads to high morale. A charismatic leader will demonstrate behaviour that exemplifies the tasks and values needed to fulfil the organization's vision. He / she is the ultimate team leader and makes instilling a motivational work ethic a number one priority (Mannie, 2005). Charismatic leaders use a wide range of methods to manage their image. They will show great confidence in their followers. They are very persuasive and make very effective use of verbal language

as well as body language. Despite their charm and apparent concern, the charismatic leader may well be somewhat more concerned with themselves than anyone else. Sometimes their self-belief is so high, they can easily become self-absorbed thus developing a need for admiration and worship. This may result in them believing they are infallible, and hence lead their followers into an abyss, even when they have received adequate warning from others. They may also be intolerant of challengers and so quickly replace them.

A charismatic leadership style can resemble transformational leadership because these leaders inspire and motivate their teams. The difference between charismatic leaders and transformational leaders lies in their purpose. Transformational leaders want to transform their teams and organizations whilst charismatic leaders are often focused on themselves, and may not want to change anything.

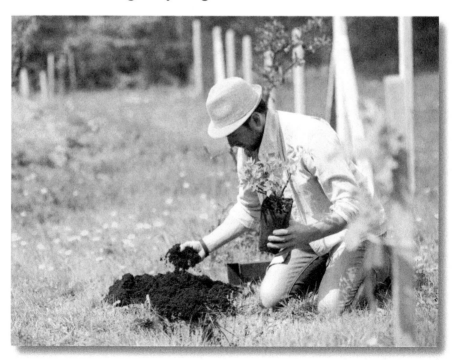

10 Gardening Jacket: **Transformational** Leadership Style

Transformational leadership is defined as a leadership approach that causes change in the organization as well as inspires positive changes in those who follow. Transformational leaders are generally enthusiastic, energetic and passionate. *This leader is considered a visionary, and he or she sets goals for the organization and develops plans to achieve them (Northouse, 2006).* Mentoring, nurturing, and empowering are characteristics of this style. The primary focus of the transformational leadership style is to make change happen in themselves, in others, and in the organization. These leaders motivate employees and enhance productivity and efficiency by providing support and guidance. They value growth, not just market share, and also the personal development of their team.

11 Company Uniform: **Transactional** Leadership Style

The "transaction" usually involves the organization paying team members in return for completion of specified tasks. The leader possesses the power to "punish" team members if their work doesn't meet an appropriate standard. Employees receive rewards, such as bonuses, when they accomplish goals. The main benefit of benefit of transactional leadership is it clarifies everyone's roles and responsibilities. Despite much research that highlights its limitations, transactional leadership is still a popular approach in many organizations. The downside of this style is that, it can be amoral, and thus lead to high staff turnover. It also limits creativity.

The underlying psychology in Transactional leadership is Behaviourism, which is illustrated in Pavlov's Classical Conditioning and Skinner's Operant Conditioning:

Classical Conditioning—Ivan Pavlov (1903) introduced classical conditioning through his famous experiments with dogs. Classical conditioning basically involves forming an association between two stimuli resulting in a learned response. He concluded we are pre-conditioned to *unconditionally* respond in certain ways to stimuli. Conditioning is thus "learning by association." John B. Watson (1920) further extended Pavlov's work and applied it to human beings using infants. Watson believed that all individual differences in behaviour were due to different experiences of learning. He famously said:

"Give me a dozen healthy infants, well-formed, and my own specified world to bring them up in and I'll guarantee to take any one at random and train him to become any type of specialist I might select–doctor, lawyer, artist, merchant-chief and, yes, even beggar-man and thief, regardless of his talents, penchants, tendencies, abilities, vocations and the race of his ancestors" —John B. Watson.

Operant Conditioning or Instrumental conditioning: B.F. Skinner (1938) introduced the theory of operant conditioning which was based on the work of Edward Thorndike (1905). Thorndike studied learning in animals using a puzzle box to propose the theory known as the *'Law of Effect'*. Skinner believed learning is a function of change in overt behaviour. Operant conditioning is a learning process that attempts to modify behaviour through the use of positive and negative reinforcement. A behaviour will increase if it is followed by positive reinforcement. It will decrease if it is followed by punishment. Conditioning is thus "learning by consequences."

Analyzing your leadership style using the Blake-Mouton Managerial Grid and path–goal theory of leader effectiveness:

⮑ The Blake-Mouton Managerial Grid is a leadership model developed by Robert R. Blake and Jane Mouton (1964). It highlights the most appropriate style to use, based on your concern for people and your concern for production/tasks. With a people-oriented style, you focus on organizing, supporting, and developing your team members. With task-oriented leadership, you focus on getting the job done. According to this model, the best style to use is one that has both a high concern for people and a high concern for the task.

⮑ The path–goal theory, also known as the **path–goal theory of leader effectiveness** is a leadership theory developed by Robert House, in 1971 and revised in 1996. It states that a good leader sets goals, provides clear direction, gets involved in goal achievement and supports his / her team. It focuses on establishing a clear *path* to *goal* achievement. With Path-Goal Theory, you can identify the best leadership approach to use, based on your people's needs, the task, and the environment that you're operating in.

Therefore, choosing the right leadership style will depend on the season or time of day (**situation**), the event (**organization**), and the individuals in attendance (**followers**). This is a key element of leader effectiveness. Sadly, though, that's not what some individuals do; they have one style and use it in all situations. It's like having only one suit, something they wear everywhere. Of course, we could all agree that wearing only one set of clothes to different occasions is inappropriate,

especially when there is a dress code in effect, but then so is having only one leadership style.

Today's leadership requirements call for a multi-style attitude. The most influential approach will include the use of multiple styles. Companies become historically recognized by the influential reach or climatic demise of their leaders.

Leadership should always be contingent (ethically) on the given circumstances, situations, and stimuli in order to remain effective. In fact, situational leadership may, at the end of the day, win the **Best Dressed** Leadership prize.

Part Two

INSPIRATION

Seven Ps Leaders
Use to Achieve Goals

A dream is just a dream. A goal is a dream with a plan and deadline. Ask yourself if what you are doing today is getting you closer to where you want to be tomorrow.

HERE ARE SEVEN *P*s LEADERS USE TO ACHIEVE THEIR GOALS:

Purpose: This is the reason for your journey. A purpose serves as a lighthouse. It gives instant focus and direction. A life without purpose is like a ship drifting aimlessly without a sail. Have a vision and a mission statement. Ask yourself what's really important to you, what you are good at, and what you would like to have achieved when you look back at the end of your life.

"Efforts and courage are not enough without purpose and direction." —John F. Kennedy

Passion: This is the fire that lights your way. Thomas Edison failed more than a thousand times when trying to create the light bulb. When asked about it, Edison allegedly said that he had not failed a thousand times but that he had successfully discovered a thousand ways to *not* make a light bulb.

"Passion is the genesis of genius." —Anthony Robbins

Perseverance: Have vison like an eagle and be persistent. Probably one of the greatest examples of persistence is Abraham Lincoln. Lincoln was faced with defeat throughout his life. He lost eight elections, failed twice in business, and his fiancée died. He suffered a nervous breakdown. However, in 1860, he was elected the sixteenth president of the United States. **Pain-** Get accustom to rejection and failure and take it in good stride. Never take things personally: no pity parties allowed. The road to success is not smooth.

"Ambition is the path to success. *Persistence* is the *vehicle* you arrive in." —Bill Bradley

Planning—Preparation—Positioning: Les Brown worked as an errand boy in a radio station. He often stayed in the control rooms and soaked up whatever he could until the deejays asked him to leave. At night back in his bedroom, he practiced. One day while Les was at the station an opportunity presented itself and he was ready. He blew away the audience and the station manager.

"It's better to be prepared for an opportunity, and not have one than to have one and not be prepared." —Les Brown

People: Invest in and form meaningful relationships. Have a good supportive network of people you can really trust who believe in you, are honest with you, and will encourage you. Networking is key. The friendship between Henry Ford and Thomas Edison spanned more than thirty years—**iron sharpens iron.** From their earliest meetings, they encouraged and inspired each other, often contributing to each other's work.

"If you want to be a lion, you must train with lions." —Carlson Gracie

Patience: Be Patient. **Patience** (or **forbearing**) is the state of endurance under difficult circumstances, which can mean persevering in the face of delay or provocation without acting on negative annoyance/anger; or exhibiting forbearance when under strain, especially when faced with longer-term difficulties. Patience is the level of endurance one can take before negativity. It is also used to refer to the character trait of being steadfast. For everything there is a time and a season.

"No matter how great the talent or efforts, some things just take time. You can't produce a baby in one month by getting nine women pregnant." —Warren Buffett

Positive Thinking: Always believe in yourself and have confidence in your abilities. "Formulate and stamp indelibly on your mind a mental picture of yourself as succeeding. Hold this picture tenaciously. Never permit it to fade. Your mind will seek to develop the picture...Do not build up obstacles in your imagination." —Norman Vincent Peale

"Positive thinking is the key to success in business, education, pro football, anything that you can mention. I go out there thinking that I'm going to complete every pass." —Ron Jaworski

TWO BONUS P'S THAT FORM THE FOUNDATION FOR ACHIEVING GOALS:

Personal Development: This is a vital part of a person's growth and maturity and is much like how you nurture a plant. People give more importance to academic and professional achievement rather than personal growth. This has caused a lot of emotional struggles.

"Personal development is a major time-saver. The better you become, the less time it takes you to achieve your goals." — Brian Tracy

Prayer: Prayer brings peace of mind in the midst of turmoil. Just trust God and have faith that all things work out for your

good. Praise Him and be thankful. Gratitude unlocks the fullness of life. It turns what we have into enough, and more. Never underestimate the power of prayer.

"Every time I have had a breakthrough in my life, it has been because of prayer." —John C. Maxwell

CHAPTER 5

The Wisdom of Failure

As we approach another year end, I look back and tabulate whether my successes have been more than my failures. It's clear that failure has left its imprint. The hardest blow came in the form of failing a major exam. The pain was crippling. It did knock me out for a bit. But, after all, how do you climb back onto the saddle when the horse has flung you off: when your plans fall to pieces? *Life will constantly test your resolve and level of commitment.*

If only we could have patience in the midst of our trials. **Coping with rejection and apparent failure is a serious matter**. John Kennedy Toole was an American novelist born in 1937. Toole's book was rejected by every publisher he approached. He began suffering from depression and paranoia. This rejection was too much for Toole, who committed suicide at the age of thirty-one. Toole's novels were rejected during his lifetime; however, posthumously he won the Pulitzer Prize in 1981. If you focus on positive thinking, even the harshest defeat is only a stepping-stone. Never let success get to your head. Never let failure get to your heart. "I didn't get consumed by losses," said the legendary NFL coach Don Shula, "and I didn't get overwhelmed by successes."

There will always be peaks and valleys. It's important to learn how to handle both. Some valleys we may want to run quickly through, however we may be required to walk one step at a time, but be assured, **it won't rain forever. The sun must shine through.** Many of us have stifled our dreams by heeding some misguided critic who implied we were not good enough. Few things in life are certain, but failure is. Failure seems to be something to avoid at all cost. Although it leaves a sour taste, we should embrace failure for the learning opportunity it provides. Failure is the oldest teacher and perhaps the wisest

of them all. Some things are impossible to completely grasp without first falling down.

We live in a culture that values perfectionism, and failure is often viewed as a sign of weakness. People become so fixated on not failing that they never move forward. *When it comes to failing, our egos are our own worst enemies.* It's easier to accept failure in private, but once the failure is obvious to everyone around you, it becomes harder to accept it. Holding onto failures for too long is destructive.

DON'T LET FAILURE HOLD YOU CAPTIVE.

Oftentimes we may be held captive by limitations placed on us by ourselves or others. **My whole life I've been told "You can't."** Failures can lead to us suffering from the "**Baby Elephant syndrome.**" When an elephant living in captivity and is still a baby, it is tied to a tree with a chain or rope nightly. The baby elephant tries with all its might to break the rope but it isn't strong enough to do so. It tries and fails many times until realizing its efforts are futile, it finally gives up and stops attempting for the rest of its life.

Later, when the elephant is fully grown, it can be tied to a small tree with a thin rope and could easily free itself by breaking the rope or uprooting the tree but because its mind has been conditioned by its past experiences, it doesn't even make the slightest attempt to break free. This powerful animal has confined its present abilities by the limitations of past experiences hence, the "Baby Elephant Syndrome."

Human beings are similar to the elephant except for one thing, we can choose not to accept the false boundaries created by others or the past.

"The mind is a powerful force. It can enslave us or empower us. It can plunge us into the depths of misery or take us to the heights of ecstasy. Learn to use is wisely." —David Cuschieri

Even if you fail, remember it's not the end of the world (yet), tomorrow is another day so pick yourself up and head back to the drawing board.

THE IMPORTANCE OF FAILURE

- **It's a learning experience:** Failure drives us to change. It represents opportunity and growth. It gives new direction. We learn one or more lessons in what we may see as a failure.

- **It builds character:** We learn how to behave when we finally accomplish our goals. The humility we gain through our failures allows us to better handle and appreciate success.

- **It makes us stronger:** It's with persistence we overcome failure to achieve success. When people fail, they feel unaccomplished and try again and again to finally reach success.

- **Your chances of succeeding increases:** Failures are the pillars for success. You gain experiences you could not get any other way. Some things can only be learned through trial and error.

➲ **Failure is a type of freedom:** Why? Because the worst has happened. Now you can relax and rebuild again.

Success does not come easy. Everyone must face one hurdle after another. If you think that once you have the success you crave, you can relax? If so, you are sadly mistaken.

"Crossing the finish line: The finish line is just the beginning of a whole new race."—Unknown

Failure can be costly, both emotionally and financially. Some industries are very unforgiving, and one or more failures could instantly get you the boot. The worst thing anyone could do is not learn from failures. In recent years, more and more executives have embraced the point of view that failure is a prerequisite to invention. "The fastest way to succeed," IBM's Thomas Watson Sr., once said, "is to double your failure rate." The growing acceptance of failure is changing the way companies approach innovation.

However, distinguishing between excusable and inexcusable failure is crucial. Managing failure is key. Some mistakes are unpardonable, for example, producing and marketing a dysfunctional product caused by poor quality control. Encouraging failure doesn't mean abandoning supervision or respect for sound practices. Managing for failure requires leaders to be more engaged, not less.

Twenty Powerful Quotes on Failure:

"You always pass failure on your way to success." —Mickey Rooney

"A failure is a man who has blundered, but is not able to cash in the experience." —Elbert Hubbard

"Failure is the tuition you pay for success." —Walter Brunell

"Feeling sorry for yourself, and your present condition is not only a waste of energy but the worst habit you could possibly have." —Dale Carnegie

"Success represents the 1% of your work which results from the 99% that is called failure." —Soichiro Honda

"The season of failure is the best time for sowing the seeds of success." —Paramahansa Yogananda

"Success is not built on success. It's built on failure. It's built on frustration. Sometimes it's built on catastrophe." —Sumner Redstone

"Failure is the condiment that gives success its flavour." —Truman Capote

"There is no failure. Only feedback." —Robert Allen

"Remember that failure is an event, not a person." —Zig Ziglar

"Failure will never overtake me if my determination to succeed is strong enough." —Og Mandino

"It's fine to celebrate success but it is more important to heed the lessons of failure." —Bill Gates

"Do not be embarrassed by your failures, learn from them and start again." —Richard Branson

"I can accept failure, everyone fails at something. But I can't accept not trying." —Michael Jordan

"Every adversity, every failure, every heartache carries with it the seed of an equal or greater benefit." —Napoleon Hill

"Failure is simply the opportunity to begin again, this time more intelligently." —Henry Ford

"My great concern is not whether you have failed, but whether you are content with your failure." —Abraham Lincoln

"I am not discouraged, because every wrong attempt discarded is another step forward." —Thomas Edison

"Never confuse a single defeat with a final defeat." —F. Scott Fitzgerald

"Our best successes often come after our greatest disappointments." —Henry Ward Beecher

Finally, don't let the fear of failure hold you back. *Remember to take risks. If you win, you will be happy; if you lose, you will be wise.* Always find joy in your journey for, as George Bailey said it best, "**It's a wonderful life!**"

CHAPTER 6

The Glory of Rejection

If there was one topic I would say I have the authority to discuss, it would be rejection. Throughout my journey, I've faced many ups and downs. At times the downs seem to happen more than the ups, which can be overwhelming.

Rejection has historically been viewed as a form of failure. How many times have you felt that your performance was good enough, only to find yourself looking for the answers to your unexpected rejection? **Getting rejected is a part of life and something all leaders must accept**.

Rejection is one of the most brutal stakes to the heart because it deals a direct hit to the ego. There are few experiences more painful than being rejected. Dealing with rejection can be tough. A lot of people would choose physical pain rather than being rejected. Our basic human need to belong causes these incidents to stick with us throughout the years.

Glory seems to be the furthest thing from rejection because they are flat out opposites, but what people don't know is that glory is the flip side of the coin. Often the people who you think have it all are those who have endured the most rejection. Not everyone who is on top today got there with success after success. Their beginnings weren't always smooth, and they often had to face great obstacles and ridicule.

The one thing successful people have in common, though, is their approach to dealing with rejection. They don't let the naysayers hinder them. They may get knocked down, but they regroup and come back better and stronger. More often they share one characteristic: the commitment to their own success. **Rejection is unavoidable in a creative life**. Learning how to deal with rejection will keep you from plummeting into a place of immobilizing despair.

TEN TIPS FOR DEALING WITH REJECTION

1 *Have a vision and don't let anything deter you from following it.* Take courage. Put full steam into the next best opportunity you are working on. Be confident. Ask for what you want. Purpose in your heart that you will keep fighting for your dreams. How many times will you try before you decide to give up? This is your dream and you have to protect it. **Envision the future and maintain your focus.** I try every door until I have exhausted all options and yet I don't give up. Once there is a will, there is always way and I am determined to find it! "If you want something, ask for it. Accept the risk of rejection, and summon the courage to ask for it anyway." — Steve Pavlina

2 *Keep a positive mental attitude. Stay motivated.* Pick up the pieces and dust yourself off. Furthermore, don't keep complaining about the rejection. If you keep picking at a scab, the wound will keep bleeding and you will never heal. "Believe in yourself and there will come a day when others will have no choice but to believe with you." —Oscar Wilde

3 *There are valuable life lessons you need to learn* to equip you for the next phase of your journey. Ask yourself what you can learn from this. Maybe it's time to start your own business, change careers, or explore other options. "You've only got three choices in life: Give up, give in, or give it all you've got." —*Unknown.*

4 *Nothing happens before its time.* Accept that it was never meant for you at that point in time. When we get rejected, we trap ourselves in a moment of doubt and distress. Don't feel

sorry for yourself and slump into an attitude of self-pity. "When obstacles arise, you change your direction to reach your goal; you do not change your decision to get there." —Zig Ziglar

5 *Rejection offers us a chance to evolve*. Evolve and learn from experiences. Focus on personal development (spiritual, emotional, mental, social, and physical). **Turn negatives into positives** and make it a growing experiencing.

6 *Don't take it personally. Rejection is not a measure of your self-worth*. When somebody rejects you, they are acting on their own insecurities and fears. It is envy that influences rejection more often than you may think. **Have a strong support network.** You can't do it alone. There are days when it becomes too much for you. You may need a little help to get back up. *"Surround yourself with the dreamers and the doers, the believers and thinkers, but most of all, surround yourself with those who see the greatness within you."* —Edmund Lee

7 *Avoid over-thinking the rejection*. Don't torture yourself repeatedly, reliving the moments of humiliation. Don't beat yourself up and keep replaying the circumstances. *"Determination and perseverance move the world*; thinking that others will do it for you is a sure way to fail." —Marva Collins

8 *Give thanks for the bullets you dodge as a result of rejection*. When you look back you will thank God that you didn't settle for less. There was something better in store for you.

9 *Be aware of your reaction to rejection*. Life is not fair, so develop thicker skin. Don't let anyone's opinion of you change your attitude or take away your smile. Adversity can

make or break you, but it certainly reveals you. "I am not what happened to me. I am what I choose to become." —Carl Jung

10 ***Have faith and trust God*** *to direct your steps.* Things may look dismal and you may feel disappointed, but don't lose hope. Have faith that things will work out. Some things are out of your control. I trust that God will take me through those difficult moments and that gives me peace even when things don't go my way. When one door closes, try another door. Keep trying! Sooner or later the right door will open. You will have matured and be better prepared to function in your new role.

FIVE BENEFITS OF REJECTION

1 It gets you fired up as it gives you something to prove: In his first film, Harrison Ford was told by movie executives that he didn't have what it took to be a star. It added fuel to the fire and gave him something to prove.

2 It makes you more creative: In 1919, Walt Disney was fired from the *Kansas City Star*. According to his editor, he lacked imagination and had no good ideas. Rejection motivates you to find new ways to market yourself and your product.

3 It makes you work harder: Michael Jordan said, "I think that not making the varsity team drove me to really work at my game, and also taught me that if you set goals, and work hard to achieve them—the hard work can pay off."

4 It develops your character: Your response to rejection shows how you respond when things don't go your way. Are you able to let go, or do you become resentful? You also will be more supportive to others facing similar struggles.

5 It builds strength: Today, Abraham Lincoln is remembered as one of the world's greatest leaders. However, rejection followed him through much of his early life, and that better prepared him to handle ridicule in the public eye.

MY TOP TEN REJECTION QUOTES

"As I look back on my life, I realize that every time I thought I was being rejected from something good, I was actually being re-directed to something better." —Steve Maraboli

"Rejection is the sand in the oyster, the irritant that ultimately produces the pearl." —Burke Wilkinson

"Do not waste yourself in rejection; do not bark against the bad, but chant the beauty of the good." —Ralph Waldo Emerson

"You may not realize it when it happens, but a kick in the teeth may be the best thing in the world for you." —Walt Disney

"I am thankful for all of those who said NO to me. It's because of them I'm doing it myself." —Albert Einstein

"If you aren't getting rejected on a daily basis, your goals aren't ambitious enough." —Chris Dixon

"I think that you have to believe in your destiny; that you will succeed, you will meet a lot of rejection and it is not always a straight path, there will be detours—so enjoy the view." —Michael York

"Rejection doesn't mean you aren't good enough; it means the other person failed to notice what you have to offer." —Mark Amend

"Don't be offended by rejection, instead let it strengthen your belief that God has better things in store for your dream." —John Di Lemme

"Never give up! Failure and rejection are only the first step to succeeding." —Jim Valvano

Keep in mind that you will probably never get rid of rejection. You may be rejected many times until the end of your life. Rejection on the whole is painful, but viewing rejection as necessary and even positive will help you overcome it that

much more easily. It's important to recognize the hidden elements of this emotion as catalysts for productive change towards a better, stronger, more powerful you!

Remember, although the road may seem long and winding, there is a prize waiting at the finish line for you, and all those who rejected you will have to join in applauding you. Never give up, for you just may be one step away from achieving your dream.

The Power of Persistence: Never Give Up

Despite having faced numerous setbacks, I have always kept going, carrying **"Never give up, just try one more time"** as my motto. Sometimes though, it felt like every step forward I made, I was actually moving two steps backwards.

So how do you keep going when things don't seem to be working out for you? How do you not give up when everything inside you to tells you to, when it seems your investment is yielding no returns, and when your dreams seem a far stretch? What makes some people give up, while others hold on until the prize is won?

Keep focused. Be positive. Believe in yourself and your abilities. Have a good support network and actively seek out ways to help others. Be thankful for what you have. Never compare yourself to others and, most importantly, trust God and have faith.

You will face many obstacles along the path including fear, failure, rejection, financial woes, fatigue and loneliness. But don't give up. When life knocks you down, you can either stay on the ground and wallow in self-pity, or you can get back up and say this is *not* how the story is going to end. *Your dreams were given only to you for a reason. You don't need a co-signer.*

How you measure success will determine your resiliency and, ultimately, whether you deem yourself to be a success or a failure. I've met some successful individuals along the way who had become despondent because of comparisons made to peers. It's important to understand that each of us has a different race to run and will achieve milestones at diverse points. We can't all be a Richard Branson or a Bill Gates.

It is prudent to look at the lot that you have been handed and what have you done with it. Yes...I may not have achieved all of my objectives, but I have made a positive impact in the community. Constantly comparing yourself to and trying to impress others will yank the joy out of your accomplishments.

IN OUR QUEST FOR SUCCESS, IT'S THE SIMPLE THINGS WE TAKE FOR GRANTED THAT REALLY MATTER, LIKE BEING A PERSON OF INTEGRITY, A GOOD PARENT, A TRUSTED FRIEND... FOR THESE HAVE BECOME PRICELESS ATTRIBUTES IN OUR SOCIETY TODAY.

"Never mind what others do; do better than yourself, beat your own record from day to day, and you are a success." — William J. H. Boetcker

Life will throw curve balls at you and will attempt to break you down. Nothing may happen exactly as you have planned. Just when you think things are starting to turn around, life may smack you back down, but don't despair. You will get disappointed, but don't be discouraged. Life is a constant struggle with extreme lows and highs; that's why it's crucial to *always build on failure and use it as a stepping-stone.*

The Road to Success is quite bumpy and frankly curvy, so how do you keep going? It's definitely about perspective—how you look at things. My formula is to take things one step at a time. Have a clear road map, but as with traveling any path, there will be turns, potholes and roadblocks, so you must anticipate them and adjust accordingly. Keep moving forward.

"Failure should be our teacher, not our undertaker. Failure is delay, not defeat. It is a temporary detour, not a dead end . . ."
—Denis Waitley

Stepping outside of your comfort zone and making bold decisions can be empowering but scary. It definitely takes inner *strength* and *persistence* to reach your goal. You will have to believe in yourself and know what you possess. Life is like a boxing match. Defeat is declared not when you fall, but when you refuse to stand again. Know the reason you are doing this. Believe big, dream big, and your results will be big. Of course, you will have to put in the required effort and this may call for big sacrifices. **Finally, reaching your goal calls for *patience*.** This is the part we hate the most, but Aristotle said it best: "Patience is bitter, but its fruit is sweet."

"The nail that stands out gets hammered down." —Japanese proverb

Sometimes setbacks may simply mean you need to re-focus your energies on another path or improve your game plan and seek personal development. In the end, though, you become stronger and the lessons learned make you wiser.

"Just because something isn't happening for you right now, doesn't mean that it will never happen. You never know what's around the corner." —Unknown

On June 5, 2015, a door finally opened that I had been trying to open for so long. I had been heading into unknown territory. The odds were totally stacked against me. There seemed to be nothing working in my favour, yet I kept pressing on. "Don't let small minds convince you that your dreams are too big." —Unknown

The days leading up to my breakthrough were indeed the toughest. As the saying goes, **the darkest hour is just before dawn**. Well, the storm unleashed its full fury. Everything that could have gone wrong did, and then, of course, there were the dissenting voices. Friends who I assumed would always be at my side got tired of the fruitless journey. Even those closest to me really didn't understand and thought they were offering supportive advice by telling me to give up. I felt cornered and outnumbered. "Don't let someone who gave up on their dreams talk you out of yours." —Unknown

It became very difficult. I started to ask myself if it was really worth it or if I was wasting my time? What if nothing ever happened? But in those grim moments, it was really my faith in God that took me through.

"Birthing your dreams is never a painless process. It is the discomfort and pain of the undesirable position you are in that forces you to reach out to something better." —Dr. Moses Simuyemba

Then in an instant, when all hope was gone, everything changed. I was amazed. I wasn't expecting anything to happen so soon. I was just so focused on my plan and had mentally psyched myself up for the long bumpy road ahead. Yes, it had been like this for quite a while, but everybody has their day and that day was my day.

This is why it's important to always visualize the end result and not focus only on the destination—enjoy the journey. Make a conscious decision to be happy now. Keep on *smiling* because *when you're smiling, the whole world smiles with you.* Happiness increases your focus and fuels your passion. The longer the course is with no end in sight, the more it becomes

a mind game. Stop doubting yourself. Replace negative thoughts of inadequacy with positive affirmations. "I can and I will." Be patient and don't worry.

ALWAYS LET *PERSEVERANCE, DETERMINATION, COURAGE,* AND *HOPE* BE THE FELLOWS THAT ACCOMPANY YOU ON YOUR JOURNEY.

So keep trying, keep reaching, and keep dreaming. You never know what's around the corner. Although the path may be steep and the heat sweltering, just remember to keep your chin up and *never give up!* There are times you will want to give up...DON'T!

"Never give up, for that is just the place and time that the tide will turn." —Harriet Beecher Stowe

CHAPTER 8

How to Overcome the Naysayers

Naysayers can be very frustrating and annoying to deal with. They can distract or discourage you from pursuing your goals. At every step, you will encounter the naysayers. To be

successful in life, one must master the ability to overcome them.

HERE ARE FIVE WAYS TO OVERCOME THE NAYSAYERS:

1 **Ignore them.** The bigger your dreams or goals, the more the naysayers will flood in. Don't let their words sink in and take root. Avoid over thinking the criticism. Don't give them residency status in your head, redirect them to your short term memory. People will always have something negative to say. Stay focused on your **vision**. Naysayers can render a crippling blow but only if you allow them to. Let's not pretend, negative words hurt but how you internalize it can minimize the impact.

"You wouldn't invite a thief into your house, why then would you let negative people invade your mind?" —Unknown

2 **Respond don't react.** If you must engage in discussion, respond politely and respectfully. Let your emotions subside. Never respond in the heat of the moment. **If you respond wisely sometimes you can win them over.** Some of my worst critics are now my good friends. However, don't waste time trying to convince them, you can't always be justifying yourself to everyone. Pick your battles wisely. There is a difference between constructive criticism and personal attacks. Decipher which it is and if it's personally targeted to undermine you, reject it. Additionally, not all criticism is a bad thing. **Be open to listen and learn.** Constructive criticism is an assessment or observation that can give insights and lead to new opportunities. Ask, "What can I learn from this?"

"You will never reach your destination if you stop and throw stones at every dog that barks." —Winston Churchill

3 **Safeguard your Dreams.** Your dreams are precious. Be very selective about who you share your goals and dreams with especially when it's in the infancy stage. You don't have to let everyone know what you are planning on doing. This is life and not everyone will like you. Don't take it personally, it is not a measure of your self–worth. I read somewhere hurting people hurt other people. Realize that some people just like to be negative. Keep doing your best and let the negativity inspire you to prove them wrong.

"If you fuel your journey on the opinions of others, you are going to run out of gas." —Steve Maraboli

4 **Take control of your environment.** If certain individuals are constantly bringing you down it's time to eliminate them. If it's someone you cannot avoid then reduce contact with them or just tune out when they are speaking. Have a close network of people who you can really trust. I always emphasize this because your deepest wounds will not come from outsiders but those in your inner circle. Don't waste time listening to gossipers. I never listen to third parties who tell me, someone has told them something about me. It adds nothing and makes emotions of resentment swell up inside.

"People inspire you or they drain you. Pick them wisely." — Hans F. Hansen

5 **Personal development.** Make yourself stronger. Remember it's not about them. It's about you. They are just an extra in your movie whilst you have the leading role. Look at areas where you can improve and focus your energies on the things you can change. Seek continuous self-improvement. Negativity offers us a chance to evolve and learn from our experiences. Personal development (spiritual, emotional, mental, social and physical) is crucial. People always tell me I am mentally strong but this just didn't happen in a day. It's a process I keep working on daily.

"The biggest enemy you have to deal with is yourself. If there's no enemy within, then the enemy outside can do us no harm."
—Les Brown

Negativity is always all around but it's important not to let it paralyze us. Everything in life must be used as a **growing experience**. If we only receive positive feedback we would become complacent and wouldn't grow. In order to succeed, we must learn how to recognize and embrace what's beneficial and quickly discard the meaningless.

CHAPTER 9

Leadership:
the Art of Inspiring Self

Who motivates the motivator? **How does one who daily motivates others stay motivated**? Being at the top can get lonely sometimes. As a leader, everyone is constantly looking to you for guidance, support, and direction. Leading can be stressful. There is no way to avoid the constant challenges of being responsible for people, outcomes, and uncertainties in the environment. It can be daunting at times when you don't have all the answers.

WHEN THE GOING GETS TOUGH, HOW DO LEADERS STAY INSPIRED?

It's important not to become discouraged by the level of difficulties faced. If the feelings of doubt and fear are deeply embedded, failure is just around the corner.

"A positive attitude is one of the most valuables assets a person can have in life. It can help you achieve things that may seem impossible to happen." —John C. Maxwell

Your team's motivation is a direct reflection of the enthusiasm you transmit. When you are motivated, you are confident, energized, and productive. However, when you are not motivated you lose your edge.

Leadership is a dynamic process involving the leader, the team, tasks, and threats (organizational and external variables). At the heart of effectiveness is the leader.

SEVEN WAYS LEADERS STAY INSPIRED

1 **Believe in your purpose**: Are you pushing forward passionately or simply going through the motions? To be your best, you need to give serious thought to what makes you flourish and succeed. To lead others, you must first start learning about yourself, how to manage yourself, and demonstrate self-leadership.

"You can't sell it outside if you can't sell it inside." —Stan Slap, management consultant

2 **Find a good peer group or support network:** Have a mentor or someone whose leadership style you would like to emulate. It doesn't matter how naturally talented you are, you may still need a coach to help you stay on track. Someone who will champion you and encourage you to keep running.

"Not a day goes by that I don't think about my dad. I remain inspired by the genuine depth with which he loved the people who worked with him." —Chester Elton, *New York Times* best-selling author

3 **Be True to Yourself:** Work on your inner compass. What is your core purpose? What are your guiding principles? *Know the values, standards, and qualities that guide you.*

"I am not bound to win, but I am bound to be true. I am not bound to succeed, but I am bound to live by the light that I have. I must stand with anybody that stands right, and stand with him while he is right, and part with him when he goes wrong." —Abraham Lincoln

4 **Focus on the real source of your inspiration**: It demands that you survey your world and take a close look at what motivates your actions. *Are you stimulated regularly by your inspiration?*

"My personal inspirations are my parents. Yes, I admit it's a bit *cliché*, but their voices have been in my head for my entire life." —David H. Stevens, President and CEO at Mortgage Bankers Association

5 **Stay connected to the people and what you are doing**: Come down from the mountaintop and mix and mingle with your subordinates.

"For me, however, inspiration comes from solving big, meaningful problems with people I admire and love to work with. Deep, far-reaching challenges that keep me thinking, engaged, and ultimately energized." —Pete Flint, CEO at Trulia

6 **Envision the end result:** Jerry Alderman, CEO and founder of Valkre, said, "What inspires me most about being a leader is being able to see a vision over the horizon and then participating with a group of people to actually get there. When it comes to business, there is no greater reward than being able to say, we did it!"

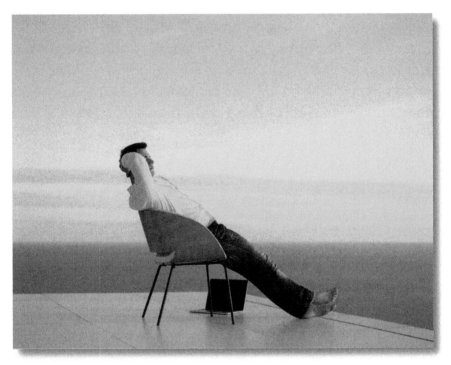

7 **Maintain equilibrium:** Finding balance is an ongoing process and a lifelong journey. *Balance is a gift you can create for yourself; no one else can do it for you.* You have to make it a priority. Some people take long runs or walks to relieve stress, while others find solace in prayer and in developing their relationship with God. Still others find relief through music, television, sporting events, and reading. A mini-sabbatical to recharge may be essential. Take time to reflect on your interests and what you are passionate about. Find what helps

you to restore your energy and find that sense of peace and renewal. *Try to create some mental space where you can relax, turn off distractions, and let yourself go.* Additionally, keep in touch with those closest to you—your spouse, your children, your friends, and your extended family.

Furthermore, **don't do it alone.** Build a strong team and delegate tasks to competent individuals who can make independent decisions on trivial matters. Additionally, break up goals into smaller, manageable sizes. Don't let your ego get ahead of you, thinking you can achieve the almost impossible in just one leap. Approaching tasks from this angle is a sure way to become disappointed.

"One of the tests of leadership is the ability to recognize a problem before it becomes an emergency." —Arnold H. Glasow

THIRTY INSPIRATIONAL QUOTES TO KEEP YOU GOING WHEN THE GOING GETS TOUGH

"An entire sea of water can't sink a ship unless it gets inside the ship. Similarly, the negativity of the world can't put you down unless you allow it to get inside you." —Unknown

"Straight roads do not make skilful drivers." —Paulo Coelho

"A bend in the road is not the end of the road. Unless you fail to make the turn." —Helen Keller

"Every time you quit, someone else gets your prize." —Robert Kiyosaki

"No one can destroy iron, but its own rust can! Likewise, none can destroy a person, but his own mind-set can!" —Ratan Tata

"Promise yourself to be so strong that nothing can disturb your peace of mind." —Christian D. Larson

"You don't have to see the whole staircase, just take the first step." —Martin Luther King Jr.

"Don't judge each day by the harvest you reap but by the seeds that you plant." —Robert Louis Stevenson

"What lies behind us and what lies before us are tiny matters compared to what lies within us." —Ralph Waldo Emerson

"God will make a way where there seems to be no way." —Don Moen

"All our dreams can come true if we have the courage to pursue them." —Walt Disney

"Even the darkest night will end and the sun will rise." —Victor Hugo

"Never lose sight of your dream, even if you have to wear glasses." —Unknown

"No one has the power to shatter your dreams unless you give it to them." —Maeve Greyson

"Life is not fair—get used to it!" —Bill Gates

"If your dreams don't scare you they are too small." —Richard Branson

"The sky is filled with stars, invisible by day." —Henry Wadsworth Longfellow

"At any moment, the decision you make can change the course of your life forever." —Tony Robbins

"If opportunity doesn't knock, build a door." —Milton Berle

"In the middle of difficulty lies opportunity." —Albert Einstein

"Our greatest weakness lies in giving up." —Thomas Edison

"Believe you can and you're halfway there." —Theodore Roosevelt

"Obstacles can't stop you. Problems can't stop you. Most of all, other people can't stop you. Only you can stop you." —Jeoffrey Gitomer

"There is nothing in a caterpillar that tells you it is going to be a butterfly." —Buckminster Fuller

"A river cuts through a rock not because of its power, but its persistence." —Unknown

"The harder the conflict, the more glorious the triumph." —Thomas Paine

"Faith is like a radar that sees through the fog." —Corrie Ten Boom

"When the world says, 'Give up,' Hope whispers, 'Try it one more time.'"—Unknown

"I will prepare and someday my chance will come." —Abraham Lincoln

"Never, never, never give up!"—Winston Churchill

Part Three

FOLLOWERSHIP

CHAPTER 10

The Seven Types of Followers Part 1

As a leader, have you ever had team members who showed little enthusiasm for your ideas or subordinates who complied with your decisions more out of duty than eagerness?

WHAT IS FOLLOWERSHIP?

Followership is the capacity of an individual to actively follow a leader. Followership is the reciprocal social process of leadership. The study of followership is essential to a better understanding of leadership, as the success and failure of organizations is not only dependent on how well a leader can lead, but also on how well the followers can follow. Followers play an active role in organization, group, and team successes and failures.

WHY DO LEADERS NEED TRUE FOLLOWERS?

Followers are an essential part of the leadership equation. Without good followers, becoming a good leader is difficult. As the proverb says, "He who thinks he leads, but has no followers, is only taking a walk." Everyone aspires to be a leader but the chief ingredient that makes a leader effective is the followers. *A good leader will not underestimate the power of followers. A good leader knows the importance of followers and is aware of the type of followers he has.*

Followers impact leaders and the leadership process. **Followers provide the horsepower to organizational performance** as they are the primary contributors to the success of any organizational outcomes. Therefore, *improving followership influence will have a beneficial impact on business performance.*

"Focusing on leadership alone is like trying to understand clapping by studying only the left hand." —Jonathan Haidt

People display followership when they express, through their words or actions, respect and support for a person they view

as their leader, and openness to being influenced by that person in that capacity. **One could argue that any good leader is in turn a good follower**. All leaders have their own leaders. *Followership can take on a shifting role perspective.* In some situations, an individual may be a leader and in others a follower, depending on the context of the organizational goals.

THE LEADERSHIP THEORIES

The Leader-Member Exchange (LMX) theory of leadership focuses on the interactions between leaders and followers and understands that it is these interactions that are the centre of the leadership process. Under this theory leaders differentiate their followers based on their perception of their followers' competence/skills, trustworthiness, and motivation to assume greater responsibilities. Leaders then treat those with high LMX differently and prefer them to those who have low LMX.

Contingency or Situational models state the effectiveness of a leader's behaviour will be contingent upon the organizational situation. Different situations call for different styles of leadership, and the effectiveness of a leader's approach depends upon the needs of the specific situation. Leadership styles and situational control can be matched either by changing the leader's personality or by changing the individual's situational control in order to affect organization or group performance.

The days of leaders saying "Jump!" and subordinates asking "How high?" are over. People are either on board with your leadership or they are not. It's not so simple. The influencing

process is made complex because *followers are not a monolithic group*. Leaders wanting to build high performing teams need to be aware of the important role followership plays in group dynamics and team performance. Over the years, only a handful of researchers have attempted to study, segment, and speak about followers in some depth:

- ⮑ **Robert Presthus**, in 1962, created a theory of organizational life that defined three unique types of workers: Upwardly Mobiles, Ambivalents, and Indifferents.

- ⮑ **Robert E. Kelley**, in 1988, developed a theory of followers describing five types: Conformist, Passive, Alienated, Exemplary, and Pragmatic.

- ⮑ **Ira Chaleff's** *Styles of Followership* (2003) proposes four distinct follower types: Resource, Individualist, Implementer, and Partner.

- ⮑ **Barbara Kellerman**, in 2007, described a typology of followership based on the level of engagement: Isolates, Bystanders, Activists, Participants, and Diehards.

- ⮑ **Roger Adair**, in 2008, proposed the 4-D Followership Model with four distinct types of workers: Disgruntled, Disengaged, Doer, and Disciple.

- ⮑ **The Curphy-Roellig Followership 2010 Model** builds on some of the earlier followership research of Robert E. Kelley, Ed Hollander, and Barbara Kellerman, and consists of two independent dimensions and four followership types: Self-Starters, Slackers, Brown-Nosers, and Criticizers.

MY ONGOING RESEARCH OF LEADERSHIP HAS LED ME TO PROPOSE SEVEN TYPES OF FOLLOWERS:

The Seven Types of Followers

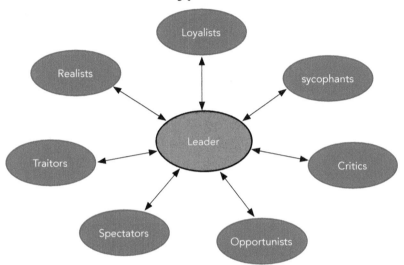

1 **Sycophants:** the flatterers—yes people. They cannot be relied upon to give critical feedback if the leader is heading in a direction that conflicts with the purpose or values of the organization. They never point out problems or raise objections; they will avoid any resistance and will defer to the leader. Sycophants are not truthful (if you say the sky is green they will say yes) and can set the leader up for a great fall. Be wary of them.

2 **Critics:** the opposition. The detractor's goal is to challenge and question the leader's every behaviour and policy. They can be classified as disgruntled. Perhaps for some reason they

were not recognized or awarded a promotion they felt they deserved. They are frequently the first to greet new employees and tell them "how things really work around here." Critics show their true colours so you know what to expect.

3 **Realists:** the constructive critical thinkers. These types provide constructive criticism and interact with the group and the leader. If they agree with the current course of action, they will back the leader 100 percent. Alternatively, if they disagree, they will challenge the leader, offering constructive alternatives to help the leader and organization achieve their goals. Realists are especially important to keep close depending on the magnitude of your project, but they can also curb creativity.

4 **Loyalists:** the genuine supporters. They are highly engaged and work hard to support the leader. They are reliable and dependable. They are highly satisfied, productive, passionate about the team, and will exert considerable effort to make it successful by always giving suggestions. Loyalists can be counted on to get the job done. However, because of their biased admiration for the leader, they can provide the leader with misguided feedback in their assessment of the leader's talents and abilities. They are good to have close especially in low moments, such as failed projects or poor performance to give much needed reassurance.

5 **Traitors:** the silent haters and conspirators. They are very good actors. They are hard to spot (until it's too late), as they have gained the leader's trust. They have strong negative emotional feelings about the leader and secretly work to undermine that person. They are the Judases. *Et tu, Brute?* Traitors are treacherous and inflict the deepest wounds. In

the case of some negative event, they are quick to publicly denounce the leader.

6 **Spectators:** the observers. They are neither here nor there and just stand on the side-line. They just work for their salary and don't get involved. They are disengaged with the organization or task and hold a position of neutrality about the leader. Spectators do their job and nothing more. They are passive.

7 **Opportunists:** the freebooters. They have a price and can easily be bought. They like to be close to the powerful, and their allegiance is to whoever is on top at the moment. You can see them in full swing at political campaigns. In the blink of an eye, this welcoming committee can become a lynch mob. Opportunists do everything openly to get noticed and love to be rewarded. They see the leader as a means to an end (promotion).

"Too often we enjoy the comfort of opinion without the discomfort of thought." —President John F. Kennedy

It is important for leaders to conduct a periodic **SWOT** (Strengths, Weaknesses, Opportunities, and Threats) analysis and be honest about their skill set and abilities.

Followership type is *not* a fixed state. An individual might move from one type to another depending on external conditions, changing perceptions, or a leader's conduct. For example, an opportunist could easily become a critic if the opportunist sees things are not going in the opportunist's favour. A team of experts at Gallup spent decades gathering data about leadership.

They conducted over 20,000 in-depth interviews with senior leaders, a million plus studies of work teams, fifty years of Gallup Polls about the world's most admired leaders, and 10,000 Gallup studies of followers from multiple cultures around the world. All this research was geared toward answering one question: Why do people follow their most influential leader?

The findings about leaders concluded that the most effective leaders understand their followers' needs. The best leaders were found to be in-touch with the needs of their followers. Instead of presuming to know what their followers needed, *the most influential and effective leaders did something remarkable to understand their followers' needs: they asked them. They talked to them. They listened.*

Good leadership begins with knowing yourself and understanding the people who are following you. **Leadership is not a right, but it is a privilege given by the followers**. Understanding the types of followers—their motives and underlying psychological drivers—and who is in each camp is critical to knowing how to influence.

The Sensational Sound of Leadership: The Seven Types of Followers Part 2

Precision! Perfection! I hear ♫ music in the air entrancing the senses and I am compelled to go there.

The orchestra grew by accretion throughout the eighteenth and nineteenth centuries; however, the twentieth-century orchestra had become far more flexible than its predecessors. The 1970s saw the introduction of charismatic and transformational leadership.

The main figure in the orchestra is the conductor. Conductors act as guides to the orchestras. A conductor's job may look easy, but it's one of the most demanding. It's leadership in motion. They are there to bring a musical score to life, communicating their own highly refined sense of the work through an individual language of gestures. While there are some common gestures, most great conductors have their own unique style.

Great conductors get the best from their people. They ensure their musicians feel significant, accepted, and secure. A conductor needs his musicians. Likewise, a leader needs his followers and needs to take time to develop his followership. The task of the leader is to get everyone in tune to make melody. The conductor needs to understand follower classification, aptitude, and motivation, and use this as a guiding tool for the development of proper leadership styles, thereby producing an environment in which the artistry of others may emerge.

"That's really the role of being a great leader—being able to help other people make the music that builds the business that you are creating." —Joe Caplan

In the previous chapter, I proposed seven types of followers: Sycophants, Critics, Realists, Loyalists, Traitors, Spectators, and Opportunists. In this chapter we will explore a little deeper to see how the leader can ensure his ensemble of followers are in unison to produce riveting music and achieve common goals.

A SYMPHONY ORCHESTRA MAY CONSIST OF SEVEN SECTIONS SYNONYMOUS WITH THE SEVEN TYPES OF FOLLOWERS:

1 **Sycophants** are the "yes people." This is the **keyboard** section (celesta, piano): pressing a key causes a padded hammer to strike strings. The strings are sounded when the keys are pressed, and silenced when the keys are released.

- ➲ Do you tend to seek the counsel of those employees that always agree with you?
- ➲ Do you speak negatively about those that challenge you?
- ➲ Do you always have to be right?

2 **Critics** are those that challenge and question the leader's every behaviour and policy. This is the **electric and electronic** section, which employs electronic music technology in its production.

- ➲ Do you let some employees get away with some things but not others?
- ➲ Do you feel that you don't have to follow the same rules as your employees?
- ➲ Do your actions correlate with the words you speak?

3 **Realists** provide constructive critical thinking and interact with the group and the leader. These are the **woodwinds** (clarinets, flutes). They are the wind instruments that produce sound through vibrations created by the user's breath as it travels through the instrument's tubes.

⊃ Do you take honest feedback personally if it's negative?

⊃ Are you open minded? Do you approach problems from a 360-degree angle?

⊃ Do you challenge your employees to think outside the box?

4 **Loyalists** are the genuine supporters. This is the **standalone** instruments section (concert harp). The harp is played with the fingertips of the first four fingers with force from the hand and arm and ultimately the upper body.

⊃ Are you a friend to your employees or their manager?

⊃ Does being accepted by employees mean more to you than disciplining them when needed?

⊃ Do you openly show favouritism to employees who support you?

5 **Traitors** are those that have strong negative emotional feelings about the leader and secretly work to undermine the leader. This is the **brass** section (trumpets, horns). Brass instruments are hollow inside.

⊃ Do you take credit for others' achievements?

⊃ Do you spend time getting to know your team?

⊃ Are you aware of what motivates them?

6 **Spectators** only engage to do their job and nothing more. These are the **percussions** (timpani). These instruments produce a sound by being struck.

⊃ Do you have coaching sessions and regular meetings?

⊃ Do you employ team building activities?

⊃ Do you assign and entrust more responsibility to others?

7 **Opportunists** are those that do everything openly to get noticed and love to be rewarded. They are the **strings** (cellos, violins). Stringed instruments make sounds when their strings are plucked with the fingers or stroked with a bow. The string section is usually located in the front.

- Do you reward your employees?
- Do you publicly acknowledge their good work?
- Do you recommend staff for training and development?

"A real leader faces the music even when he doesn't like the tune." —Arnold H. Glasow

A dysfunctional team can be unproductive. The duty of a leader is to indicate the right tempo and to get everyone focused on understanding the importance of their various roles. One person off tempo can ruin the whole performance. Therefore, achieving synchronization is needed to produce the sweetest melody. Great leaders build and orchestrate synergistic, high-performance teams that are more powerful than the sum of their parts.

TEN SKILLS REQUIRED TO BE A GREAT CONDUCTOR—A LEADER

1 **Selection:** The conductor recruits the best players. His team also consists of a concertmaster who leads the pre-concert tuning and handles the technical aspects of orchestra management. This person usually sits to the conductor's left.

2 **Vision:** The first task of the conductor is to convey the interpretation of the goals to the performers. They start with a musical score and a clear idea of how it should sound. Only then do they attempt to recreate in real time their musical vision.

3 **Influence:** Great conductors lead. With a quick move of their baton, they decide when the sound starts and stops. They inspire and create excitement without imposing their authority.

4 **Visibility:** The conductor is visible. He stands on a platform so every single member of the orchestra can see him.

5 **Persistence:** Conducting is more difficult than playing a single instrument. You have to put in the hard work with the ensemble of followers.

6 **Passion:** Great conductors are swept up in the music. They are passionate. The leader's passion is infectious and generally seeps through the organization.

7 **Purpose:** The conductor keeps his back to the audience. Leaders are aware of the audience (shareholders, board of directors) but their focus is on the players.

8 **Communication:** The best conductors are the best listeners. They can tell when there is discord in the camp.

9 **Emotional Intelligence:** Great conductors are aware of their gestures and impact. They have to be precise, or their musicians will not be able to follow. Everything done is intentional.

10 **Team Focus:** The conductor shares the spotlight. When the concert is over and the audience is clapping, he turns to them and takes a bow, and then immediately turns to the orchestra and invites them to stand and bow as well.

"I've always found that the speed of the boss is the speed of the team." —Lee Iacocca

At the end of the performance if you get a standing ovation from the audience (shareholders) and judges (board of directors) and shouts of "encore," you can rest assured the performance will be immortalized. There is a reason why certain performances live on in memories, decade after decade, and it is invariably down to that figure on the podium—the leader doing so much more than just waving hands in the air.

CHAPTER 12

How to Motivate Employees in Ten Easy Steps

Do your employees drag themselves into work? When you ask them to stay back for a meeting or complete an additional task, do they immediately jump into action, object, or agree

reluctantly? **When employees don't feel appreciated, they will not go the extra mile**. The clock is at the uppermost part of their minds.

To motivate individuals, one must understand human nature. Human needs are an important part of human nature. As a leader, you must recognize these needs because they can be powerful motivators.

LEADERSHIP AND HUMAN BEHAVIOUR (MASLOW, HERZBERG, MCGREGOR AND VROOM)

Maslow's hierarchy of needs is a theory in psychology proposed by Abraham Maslow in his 1943 paper, "A Theory of Human Motivation." His theory which he subsequently extended is based on satisfying inherent human needs in priority culminating in self-actualization. Maslow described human needs as ordered in a hierarchy—we are motivated primarily by a need only if lower level needs have been met.

Maslow's hierarchy of needs is often portrayed in the shape of a pyramid with the more basic needs at the bottom:

1 **Physiological needs**: At the bottom of the hierarchy are the basic needs being water, food, shelter and sex, etc.

2 **Safety needs:** The second level is safety needs which includes protection from elements, security, order, law, stability, etc. Once individuals have basic nutrition, shelter and safety, they attempt to accomplish more.

3　**Belonging needs**: The third level of need is "Love and Belonging", which are psychological needs.

4　**Self-Esteem needs**: The fourth level is "Esteem" needs such as self-esteem, achievement, independence, status, prestige, managerial responsibility, etc.

5　**Cognitive needs**: Cognitive needs is the expression of the natural human need to seek knowledge and meaning.

6　**Aesthetic needs**: Then there is the "Aesthetic" level, which is the need for harmony, balance and beauty.

7　**Self-Actualization needs**: Once a person has reached the self-actualization state they focus on themselves and try to build their own image.

8　**Transcendence needs**: Maslow later divided the top of the triangle to add self-transcendence which is also sometimes referred to as spiritual needs. Maslow's self-transcendence level recognizes the human need for ethics, creativity, compassion and spirituality.

It is important to note that self-actualization is a continual process of becoming rather than a perfect state one reaches of a 'happy ever after' (Hoffman, 1988).

The first four levels are known as *Deficit needs* or *D-needs*. This means if the needs are not met, they make us uncomfortable and we are motivated or driven by these needs. However, fulfilling these needs alone are not motivating.

The last four needs, he identifies as growth needs: we can never get enough of these. We are constantly motivated by these needs as they pertain to our growth and development.

GOING BEYOND MASLOW

Maslow's theory still remains very popular today due to its simplicity and relevance. Other researchers have further refined them, mainly in the area of organizations. Herzberg, and McGregor's research are all closely tied to Maslow's theory.

Herzberg's motivation-hygiene theory or Two-factor theory (1959) states that there are certain factors in the workplace that cause job satisfaction, while a separate set of factors cause dissatisfaction.

Two-factor theory distinguishes between:

- ⮑ **Motivators**: Motivators give positive satisfaction arising from intrinsic conditions of the job itself, such as recognition, responsibility, achievement, or personal growth.

- ⮑ **Hygiene** (Dissatisfiers) **factors**: The term "hygiene" is used in the sense that these are maintenance factors. These are extrinsic to the work itself, and include aspects such as company policies, supervisory practices, or wages/salary.

Hygiene factors must be present in the job before motivators can be used to stimulate a person. Therefore, you cannot use motivators until all the hygiene factors are met. If the factor is not met, then it becomes a *Dissatisfier*. People are only truly motivated by enabling them to reach for and satisfy the factors that Herzberg identified as real motivators, such as achievement, advancement and development, which represent a far deeper level of meaning and fulfilment.

Herzberg believed that businesses should motivate employees by improving the nature and content of the actual job through certain methods. These include:

- ⮑ **Job enlargement** is an increase in job tasks and responsibilities to make a position more challenging.

- ⮑ **Job enrichment involves** assigning additional responsibility normally reserved for higher level employees.

- ⮑ **Empowerment** means delegating more power to employees make decisions and to transform those decision into desired actions.

Douglas McGregor developed two theories of human behaviour at work: Theory X and Theory Y (1960). According to these theories, there are two types of employees that managers may encounter in the workplace:

Theory X (Autocratic Style): Theory X supposes that the average person dislikes work and will avoid it he/she can. Therefore in order for employees to be productive, they require supervision and threat of punishment to work towards organizational objectives. The management implications for Theory X, is a business would need to impose a management system of coercion, control and punishment to achieve organizational objectives.

Theory Y (Participative Style): Contrarily, the underlying assumption of Theory Y is that individuals not only like their jobs but are also willing to take on some amount of professional responsibility. Theory Y supposes that people do not need to be closely supervised in order to perform their job to the best of their ability. The management implications for Theory

X, is a business would need to create and support a working environment (or culture) where workers can show and develop their creativity.

A third style termed **Theory Z** was developed by William Ouchi (1981). This style is based on a team management approach. A leader using Theory Z continually invites team members to participate in the management decision making process.

Many managers tend towards Theory X, which generally yields poor results.

HERZBERG, MCGREGOR AND MASLOW'S HIERARCHY OF NEEDS

Herzberg's theory is a micro version of Maslow's theory in that it is focused on the work environment. McGregor's Theory X and Theory Y relate to Maslow's hierarchy of needs. It shows how human behaviour and motivation are key priorities in the workplace in order to maximize outputs. In relation to Theory Y, the organization tries to create the most synergetic relationship between the managers and workers, which relates to Maslow's needs for self-actualization and esteem. McGregor's Theory X is also based on workers caught in Herzberg's Hygiene Dissatisfiers, while Theory Y is based on workers who are in the Motivators or Satisfiers section.

MOTIVATION AND HUMAN BEHAVIOUR

Whereas Maslow and Herzberg look at the relationship between internal needs and the subsequent effort expended

to fulfil them, Victor Vroom's expectancy theory (1964) separates effort, performance, and outcomes.

Vroom's theory assumes that an individual will act in a certain way based on the expectation that the act will be followed by a given outcome and on the desirability of that outcome to the individual.

Valence x Expectancy x Instrumentality = Motivation

- ⮑ Valence is the importance that the individual places upon the expected outcome.

- ⮑ Expectancy is the belief that increased effort will lead to increased performance

- ⮑ Instrumentality is the belief that if you perform well that a valued outcome will be received.

The product of valence, expectancy, and instrumentality is motivation. It can be thought of as the strength of the drive towards a goal.

These theoretical insights form the basis for understanding motivation and human nature. However, another important factor of motivation is the leader. Followers also look to the leader as a source of motivation and inspiration. Leadership consists of understanding what motivates others and harnessing that desire to serve the common good.

"A good leader leads the people from above them. A great leader leads the people from within them." —M.D. Arnold

HERE ARE TEN EASY TIPS TO MOTIVATE YOUR TEAM:

Connect with your team: As a leader you should be seen. Be visible. Make your presence felt. Don't just lock yourself in your office for the whole day and only communicate with staff when you want something done. Walk around on mornings to greet staff, and take quick walks through the office during the day. Share motivational quotes and positive insights. Get to know your employees. Find out about their interests. Remember what you discussed when you see them. They will appreciate your attentiveness.

"Leadership, like coaching, is fighting for the hearts and souls of men and getting them to believe in you." —Eddie Robinson

Show that you care: I can't emphasize this point enough. If a staff member is on extended sick leave or loses a family member, pick up the phone and call them. Be genuinely sympathetic. Send a card or flowers. If one of your employees passes away, try to attend the funeral service. Furthermore, don't just focus on getting a replacement. Your staff won't forget this type of behaviour. I had a supervisor who had poor people skills. Her sole fixation was on results, and, sadly, when she retired none of the staff chose to stand up and say anything about her. It was a very short retirement programme.

"Nobody cares how much you know, until they know how much you care." —Theodore Roosevelt

Be fair and neutral: We know too well about office politics and favouritism. It's really sad when employees can tell who will be getting the next promotion based on a manager's relationship with some employees. Don't hold personal grudges, send angry emails, swear, lose your temper, or ignore your staff, especially in front of other employees. Give constructive feedback rather than criticism. Treat everyone with respect.

"If you treat people right they will treat you right 90% of the time." —Franklin D. Roosevelt

Advocate for your staff: Exhibit loyalty to your employees. In some cases if a complaint is made against an employee, the manager is quick to jump in, and suddenly all the good the employee has done is cast into the sea of forgetfulness. Don't be the judge, jury, and executioner. When your people are facing difficult challenges and morale is sinking, be the ultimate leader and take the bullet for your team.

"A great leader doesn't care about being the leader, but instead cares about the mission, the vision, and the people they are leading." —Scott Williams

Empower employees: Micromanaging by breathing down someone's neck all the time can be very disheartening. Sometimes knowing when to step back and let your employees do their work is what they need. Encourage your workers to come up with ideas. Give them responsibility. Let them lead a project. Delegate and assign tasks. Recognize the different types of employees; some may rely on this style to effectively perform but most will loathe it.

"The best leader is the one who has sense enough to pick good men to do what he wants done, and the self-restraint to keep from meddling with them while they do it." —Theodore Roosevelt

Maintain open and honest communication: Keep employees informed. Don't let them have to hear of upcoming changes through the grapevine. Make sure top management is available and engaging. Have an open-door policy where you can be seen as approachable to your subordinates. Create an environment where employee ideas and suggestions are valued. Don't have surveys and suggestion boxes then ignore feedback when it is given.

"The art of communication is the language of leadership."–*James Humes*

Champion team building activities: Encourage a family atmosphere at work. Recognize birthdays and have regular meetings and office activities. Promote events like talent shows, group breakfasts or luncheons, and other activities that

promote a sense of togetherness and belongingness. You may want to host some of these activities off-site for a change of scenery.

"Managers light a fire under people; leaders light a fire in people." — Kathy Austin, management consultant

Reward and recognize: Always reward staff for good work. Offer incentives. Recognize employees by communicating to them the great job they are doing. Rather than just recognizing top performers include those who are improving or doing their best. Additionally, don't just wait for special occasions for recognition. Give continuous specific thank yous. Additionally, show employees the results of their hard work. Make them feel as though they are a major part of the business. Keep them up-to-date with the company's performance to motivate them to give more.

"A ruler should be slow to punish and swift to reward." —Ovid

Provide training: One of the top reasons employees leave a company is lack of development opportunities. Staff members can interpret an employer's unwillingness to invest in training as a disregard for their professional development. Acknowledge and encourage individual employee strengths, recognize different skills that employees possess, and recommend training. Subsequently, if a staff member expresses a desire to move to another department, support their wishes. Don't be an obstacle to them.

"Before you are a leader, success is all about growing yourself. When you become a leader, success is all about growing others." —Jack Welch

Promote employee development: Grant time off for employees to pursue projects, family commitments, and educational or personal development programmes. Take an interest in their progression. Where possible be flexible. If employees have to go through red tape to get time off, they will decide to call in sick. Work with them to reach a suitable arrangement. Have ways for them to make up the hours. Discuss options; don't just give them the axe.

"Great leaders don't blame the tools they are given. They work to sharpen them." —Simon Sinek

Take action: Let employees see that you are really interested in them and are taking the necessary actions to improve their work environment. You may not please everyone, but in the end you will gain their respect.

"We are interested in others when they are interested in us" —Publilius Syrus

CHAPTER 13

The Leader's Toolkit: Ten Tools to Build an Effective Team

The most effective leaders build their relationships through trust and loyalty, rather than by fear or the power of their

positions. The difference between success and failure is a great team. As a leader you are expected to get results, which can only be achieved through people. *Talent itself is not the chief criterion of an effective team*. Many of us spend a large portion of our lives at work, and studies have found happiness is a good predictor of performance. Happy employees consider their jobs more meaningful and are more committed to the company.

UTILIZING THE FOLLOWING TOOLS CAN HELP A LEADER TO BUILD A TEAM THAT RUNS LIKE A WELL-OILED MACHINE:

Adhesives—Navigating the Four Stages of Team Development (forming, storming, norming, and performing): This requires the leader to be a harmonizing influence and not take sides. Pay attention to conflicts when they arise. Synergy on teams is achieved when team members feel comfortable with each other, and that requires collaboration. Therefore you must:

- Design a culture where team members are treated like family.
- Show you genuinely care.
- Champion team building activities.
- Spend time as a team with the focus of building stronger connections in a fun atmosphere.

Remember, it doesn't have to be about business 100 percent of the time. Take a break from the office and hold a team gathering elsewhere.

Level—Renewing Vision and Creating Hope: Communicate vision in a way that will keep your team fired up. Ensure each member on your team is on the same page. Make yourself always available. Keep the team on track by making sure everyone is up-to-date with information. *Define roles, give clear direction, but also grant independence.* Goals should be SMART (Specific, Measurable, Attainable, Realistic, and Timely). Effective teams require clearly-defined goals. This creates better team cohesion and productivity. Emphasize the importance of each team member's contribution and demonstrate how all of their jobs operate together to move the entire team closer to its goal.

Claw Hammer—Building and Fixing Relationships: Cultivate heart-centered connections with others. Communication is one of the most important elements to a strong team performance. Keep communication clear, open, and honest. *Encourage listening, brainstorming, and respect for individuality.* Strong teams focus on the strengths of each other and not the faults. Cultivate positive emotions by creating a culture of gratitude and appreciation for one another. Recognition is key. When you express genuine appreciation to your team, they will respect you and want to impress you even more.

The **Myers-Briggs Type Indicator** (MBTI) is one of the most popular widely used personality assessment tools to measure personality characteristics. It is commonly used in business to encourage teamwork and improve communication among different personalities. The MBTI is a proven tool that promotes better understanding, communication, and creativity for both employees and managers by:

- ⮑ Acknowledging and working with differences.
- ⮑ Actively understanding differences within a team.

⮑ Improving and embracing different forms of communication.

⮑ Encouraging the strengths of each distinct personality type.

Screwdriver—Core Values: A resilient organization is embedded in ethical values and grounded on principle. Leaders must reinforce these to the team. Over time things change in an organization—people, strategy, finances—but its values should not. If these are allowed to degenerate, a team no longer has any unifying core, and it will fragment. Values should never be compromised. If you demonstrate and stand on ethical principles, you will build teams that work together for the greater good of the organization and perform to their optimum potential.

Socket Wrench—Embrace Flexibility and Change: Loosen bureaucracy by encouraging creativity and welcoming feedback. Creative input should be encouraged from every team member on every project. *Consider each employee's ideas as valuable.* Remember that there is no such thing as a stupid idea. Foster an environment where everyone feels comfortable sharing their ideas. *Create a safe space for failure.*

Needle Nose Pliers—Business Analytics: This is a foundational catalyst to better and more intelligent decision making. Good decisions are the building blocks of great business performance. Leaders that embrace the fundamentals of best practice business analytics ask three simple questions:

⮑ How are we doing?

⮑ Why are we achieving above, below, or on par results?

⮑ What should we be doing next?

It would be beneficial to conduct a SWOT (Strengths, Weaknesses, Opportunities, and Threats) team analysis at this stage.

Cordless Drill and Bits—Strategy: When tackling big projects that require lots of energy and effort, it is more effective to break them into small sections and lay a solid foundation for team expectations. This gives a sense of purpose and accomplishment. Don't try to achieve everything in one giant leap. This can lead to disenchantment within the team. A series of short-term, attainable goals makes progress easier. Acknowledge and discuss progression at every stage relative to the overall objectives.

Crosscut Saw—Eradicate Obstacles: Eradicate those that limit productive work. *Empower your employees.* Be sure to talk with members about the advancement they are making toward established goals so that employees get a sense both of their successes and the challenges that lay ahead. *Provide opportunities for growth.* Re-prioritize staff development programs and provide training and resources that will help to strengthen job satisfaction. Coaching and mentoring are crucial to each member's development. Good leaders nurture their teams to encourage growth and guide them towards achieving their goals.

Tape Measure—Measure Performance and Results: The leader is supposed to find out what motivates a team and reward the members for good performance and efforts made. Performance needs to be meaningfully rewarded. Discuss the following with your team:

- ➲ What do we really care about in performing our job?
- ➲ What does the word success mean to this team?

↻ What other actions can we take to achieve our objectives?

It's important to have clear units of measurement that will indicate levels of progress. In many organizations, appraisals are poorly conducted and rated unhelpful by those who are evaluated.

Utility Knife—Trimming and Pruning: Each employee must be held responsible for meeting goals and for the outcomes. While the utility knife may not be the most exciting of the tools, it's a tool every leader must use. You just can't fit a square peg into a round hole. There are times when you can lead a horse to water but you cannot make it drink. The time comes when one must cut off dead branches or chisel away rough edges. If your efforts have failed to bring some team members in alignment, your last option may be to reassign them to another project for which they are better suited, to relocate them to a different unit, or to finally let them go.

IMPORTANT TRAITS OF HIGH PERFORMING TEAMS

Synergy: Team members complement each other's talents, strengths, and weaknesses. Communication at this stage is transparent and honest, and all information is shared openly.

Commitment: Team members are fully committed to the team's success. They give 100 percent and are willing to the go the extra mile when needed.

Accountability: Team leadership is shared, and members hold each other accountable for the achievement of goals. There is a sense of ownership. The entire team feels a joint sense of ownership for their collective results, and they behave like owners.

Purpose: The team develops shared goals, purpose, and core values aligned with the organization's needs.

Growth Mind-set: There is a growth mind-set. Team members seek feedback that will help them improve performance. Constructive criticism is seen as a positive.

TEN QUOTES TO INSPIRE A GREAT TEAM

"The ratio of We's to I's is the best indicator of the development of a team." —Lewis B. Ergen

"Talent wins games, but teamwork and intelligence win championships." —Michael Jordan

"Regardless of differences, we strive shoulder to shoulder … Teamwork can be summed up in five short words: 'We believe in each other.'" —Unknown

"Individual commitment to a group effort—that is what makes a team work, a company work, a society work, a civilization work." —Vince Lombardi

"Coming together is a beginning. Keeping together is progress. Working together is success." —Henry Ford

"Unity is strength … when there is teamwork and collaboration, wonderful things can be achieved." —Mattie Stepanek

The nice thing about teamwork is that you always have others on your side. —Margaret Carty

"Many hands make light work." —John Heywood

"Sticks in a bundle are unbreakable." —Kenyan proverb

"Remember, teamwork begins by building trust. And the only way to do that is to overcome our need for invulnerability." —Patrick Lencioni

In conclusion, leaders create the right climate, lead by example to encourage feedback, and prioritize the development of people. When these **"nuts and bolts"** are in place, staff will be engaged, happy, and productive!

CHAPTER 14

The Two Most Important
Words a Leader Can Say
to their Team

As we take time the time to pause, reflect, and plan ahead—envisioning that the New Year will bring far more successes. It's important to remember all those who have helped us along the way. **Saying** thank you **may seem trivial, but it is essential for leadership success.** *Servant leaders* engage the world with gratitude and always look for the opportunity to say thank you.

"Organizations exist to serve. Period." —Tom Peters

"We need to move from the leader as hero, to the leader as host." —Margaret Wheatley

Unfortunately, many leaders don't express gratitude enough. We should not wait until the end of the year to do so. Showing gratitude should be a continuous practice throughout the year. It's important to always recognize the little things that others do.

"Servant leadership is key to surviving and thriving in the 21st century." —Ken Blanchard

You cannot achieve overall goals alone. It can only be done through the assistance of your team. Saying thank you can improve your personal leadership brand and your influencing scope. We say thank you because we want someone to know we value what they've done for us and how much they mean to us. It reassures others their help was appreciated, and it encourages further commitment and supportive behaviour. Waiting too long to thank someone can result in those you lead having harsh feelings. People like to be recognized in the moment, not as an afterthought.

According to psychologists, these words also benefit you. Studies have suggested that being grateful can improve health and well-being, strengthen social relationships, and produce positive emotional states.

Don't just say, "Thanks." Say, "**Thank you so** much for helping me with . . ." Feeling gratitude and not expressing it is like wrapping a gift and not giving it. It's also important to remember gratefulness has to come from the heart so that your body language and face portray it simultaneously. When expressing your gratitude, be timely, specific, and genuine. Don't be abrupt or insincere. Say it with meaning and intent.

Default thank-you notes or cards are good; however, the appreciation lacks either that personal touch or the importance of the leader clearing their schedule to express thanks. For many of us, expressing gratitude may be a common occurrence, so we tend to think nothing of it.

HERE ARE 3 TIPS TO MAKE PRAISE AND RECOGNITION A HABIT:

1 **Make praise and recognition part of your schedule**. Set aside 10 mins a day to say thank you to your employees and peers. Take time in meetings to thank your team and acknowledge individual efforts. Handwrite a thank you note whenever possible.

2 **Recognize publicly**. If it's in an email remember to carbon copy other staff members. Praise in secret is not very rewarding. Let others know the great job the individual is doing openly. It will be more meaningful and greatly appreciated by them.

3 **Incorporate praise and recognition into your culture.** Some companies are adopting an "Applause" system, which is an internal way members of an organization can recognize each other by sending certificates of recognition. Champion this initiative and encourage employees to thank each other. The drawback in this method is it can become an institutional process rather than a sincere gesture as employees may feel obligated to participate. It also must be properly managed to ensure that the focus is kept on acknowledging peers who are going above and beyond rather than trivial unrelated work matters.

With all the demanding schedules and professionalism in today's workplace, we sometimes overlook the fact that people want to feel appreciated, and a simple "thank you" maybe all it takes. It's okay to show thanks or write it down, but if the opportunity presents itself, there is nothing that can take the place of saying it. It's important to make gratitude a high priority. Psychologically, it plays an important role for both the giver and the receiver and the benefits are priceless.

Part Four

LEADERSHIP LESSONS
AND LIFE LESSONS

CHAPTER 15

A Key Missing Element for Leadership Success

There has been an increasing trend, as many top level executives are having to tender early resignations due to waning health. I remember one of my managers who would sit at his desk working long hours sometimes never getting up. He didn't eat on time or consume any water for the whole work day. Sadly though, it took a toll on him for the worst and eventually led to his demise.

The human body is designed to move. **Our modern lifestyle, with all of its conveniences, has made many of us sedentary**. "The amount of time spent doing sedentary activity such as sitting at a computer or watching TV has increased dramatically in recent years, more than half of the average person's waking day involves sedentary activities," Dr. Seungho Ryu, professor of occupational and environmental medicine at Kangbuk Samsung Hospital in South Korea. The result of a sedentary life is not simply a lack of fitness. There is growing evidence linking sedentary behaviour with poor health.

IF YOU DON'T TAKE CARE OF YOURSELF YOU WILL BE OF NO USE TO ANYONE.

Many leadership books discuss essentials important to success but overlook this topic. Adopting a healthy lifestyle is one of the most important factors to leadership longevity. Everyone knows that exercise and nutrition is vital to maintaining health, yet many leaders continue to lead sedentary lives. Absence of muscle contraction during long, uninterrupted stretches of inactivity increases the chances of chronic diseases.

Research has shown that regular exercise is important to aging well and living a longer life. **It is the key to a healthy**

life and wellness. Physical fitness consists of fine-tuning the human body to perform and work well. By increasing physical activity you can improve the quality of life. According to Canada's Physical Activity Guide to Healthy Living, you will gain significant health benefits just by adding physical activity to your daily routine.

"If exercise could be packaged into a pill, it would be the single most prescribed and beneficial medication in the nation." — Robert M. Butler, MD at Mt. Sinai Medical School, New York

Exercise can help prevent or delay many of the problems associated with getting older. With age, the brain shrinks however physical activity helps improve its overall functioning. Regular physical activity reduces the risk of premature death from heart disease, stroke and certain types of cancer. It also reduces the risk of developing high blood pressure; and lowers bad cholesterol and increases high density lipoproteins (HDL or the "good" cholesterol). It can aid in weight loss and reduces the risk of obesity-related diseases. When we move in a methodical and orderly way, the overall circulation improves, the blood is oxygenated more and the body rejuvenates. Exercise increases energy levels, helps to build your self-confidence and boosts your immunity.

Cardiovascular diseases (CVD) are the leading cause of death in the world. One quarter of CVD deaths are the direct result of inactivity. Physical activity can reduce the risk of colon cancer by as much as 50%, and it can reduce the risk of developing type 2 diabetes and coronary heart disease by the same amount.

AS A FITNESS INSTRUCTOR, THESE ARE THE FIVE TIPS I SHARE WITH PROFESSIONALS TO MAINTAIN A HEALTHY LIFESTYLE THAT HAVE YIELDED THE BEST RESULTS FOR MYSELF AND OTHERS.

"Two-thirds of all illness is the result of our lifestyle choices," says Dr. Edward Phillips, founder and director of the Institute of Lifestyle Medicine at Harvard Medical School.

#1: Commit to an exercise programme. <u>Get Medical Clearance from your doctor first!</u> Current guidelines from the American Heart Association call for 150 minutes of moderate physical activity per week, or about 30 minutes of exercise five times a week. With age comes a decrease in metabolism, energy and strength. If you don't work out at all, you're going to lose muscle tissue every year.

- ➲ The best exercises are those **involving multiple muscle groups** as compound exercises, for example squats with shoulder press, chest fly with alternate leg raises. I do short but effective routines. It's also critical to **work the opposing muscle**. There is no such thing as spot reduction so to see results you will have to target muscles from multiple angles.

- ➲ Exercise does not have to be time-consuming in order to be beneficial. As professionals our schedules are so crammed that slaving for hours at the gym may not be feasible. No time for the gym, No excuse! You can download free workouts from YouTube. I have over 100+ workouts from the top professional trainers.

1A: **Proper form and mind body connection** is essential. Concentrate on the muscle contraction with each movement.

Always engage your core. **Proper breathing techniques** is also important as well. **Know your body;** push yourself but know your limits. Stop if you feel dizzy or upset. Moreover, it's important to recognize problems, for example, my knees creak so I always reduce plyometric exercises since they can be hard on joints.

1B: **Make sure your exercise routine incorporates:**

- ➲ **Strength Training.** The more muscle you build, the more calories your body will naturally burn each day on its own. After the age of forty, we begin to lose bone and diseases such as osteoporosis and arthritis maybe generated. Weight-bearing exercise strengthens your muscles and bones.

- ➲ **Aerobic Exercises** increase your breathing and heart rate. These exercises help your heart, lungs, and blood vessels. Maintaining aerobic fitness through middle age and beyond can delay biological aging by up to twelve years and prolong independence during old age (British Journal of Sports Medicine).

- ➲ **Flexibility. Stretching** can prevent injury and help your body stay limber.

It has been proven that people who exercise have a longer and better life expectancy than those who do not. It's time to take responsibility for your health. It's never too late to start a fitness regimen, and there's no reason to give up existing exercise if you're in good health and your doctor approves of your activity.

HOW TO KEEP BALANCE IN AN EXERCISE PROGRAM

Start Slow. If you've been inactive for a while, you don't have to rush into exercising. It's important to build up activity gradually. Always warm up and cool down. Try beginner workouts, go at your own pace, do modification exercises where necessary and take short breaks as needed. If all you can do is walk, then walk. Walking is a perfect way to start exercising. Recently a scientific study was published where it showed that walking regularly rejuvenates the person and makes them younger and dynamic. Additionally it's important to:

- ⮕ Have **proper exercise gear**.
- ⮕ Invest in a suitable vitamin and minerals supplement for your age group.
- ⮕ You may also need a protein supplement or just add lean protein to your diet.

Focus on your reason for exercising. Have short-term goals like, losing weight for the upcoming Christmas office party; and long term goals such as, not being a health burden for your family.

Get Support. It's easier to keep going with support. Consider taking a group class or exercising with your partner, friend or work colleague. **Keep a Log and Pre-plan workouts.** I save a folder with my daily workouts for the week. It helps to keep me focused especially when I don't feel like working out. You could also seek expert help. It may be helpful to consult a personal trainer.

Celebrate your Accomplishments. It's important to feel a sense of accomplishment when it comes to your exercise routine. Be proud of yourself. One day a week on the weekends, I take a break when I have met my weekly goals and treat myself, but I don't get too crazy like do all you can eat buffets.

Have Fun. Have fun with your workouts. To make health and fitness a regular part of your life, you must enjoy it. Include some activities that you enjoy as part of your program. Try to always change things up a bit, not to get bored and to avoid a training plateau.

Stay Active. Stand more. Research has also found that people who sit for long periods were 24 percent more likely to die from health problems compared with people who sat less. But exercising for short periods does not completely counteract the risks that came with sitting for a long time. Among studies that looked at cancer type, sitting for too long was associated with a higher risk of being diagnosed with, or dying of, breast, colon, colorectal, endometrial and ovarian cancers, the researchers found. Too much sitting can also cause back pain and blood clots to develop. **Sit Less: The 20-8-2 rule.** Some experts recommend that for every 20 minutes of sitting, you should stand for eight minutes and move for two minutes. Get pinged into moving. Set your watch or alarm to remind you to stand up, stretch and take a short walk for a few minutes every hour. Walk over to a colleague's desk instead of sending an email. Hold walking meetings. Commuting to work? Get off at an earlier stop and walk to work. Sometimes I go for short walks on my lunch hour. I also take the stairs at work.

"It's not what you do once in a while, it's what you day in and day out that makes the difference." —Jenny Craig

2: **Diet is key:** Make healthy choices. Reduce your calorie intake. As we grow older our bodies need fewer calories because we are losing muscle mass. Limit your intake of highly refined, processed, sugary and fatty foods. Try swapping these foods for high-fibre alternatives. One of the best side effects of eating a high-fibre diet is that it can help to maintain or lose weight. Clinical studies have also shown that dietary fibre lowers blood cholesterol levels, consequently, improving cardiovascular health. Drink lots of water. Water burns fat and suppresses hunger. You'll also save your kidneys and liver from chronic overwork. When your kidneys are taxed from too little water, your liver has to take over. *Eating* a nutritious *diet* provides the required nutrients your body needs to keep your bones, organs and muscles in optimum *shape*. Consuming a balanced diet also improves your day-to-day mental health and well-being.

EAT BALANCED MEALS FROM THE FIVE FOOD GROUPS:

1. Vegetables and legumes/beans.

2. Fruits.

3. Grain (cereal) foods, mostly wholegrain and/or high cereal fibre varieties.

4. Lean meats and poultry, fish, eggs, tofu, nuts and seeds and legumes/beans.

5. Milk, yoghurt cheese and/or alternatives.

- *Waist Size* **Matters**: Individuals who have more belly fat, or visceral fat, are at a significantly higher risk for heart disease, high blood pressure, diabetes among others. The reason for this is that visceral fat surrounds the vital organs. A few inches on the waistline is an external sign of an increase of fat in the arteries. In a nutshell, belly fat is very dangerous! A waist size over thirty-five inches in women and over forty inches in men greatly increases the risk of chronic diseases.

- **Watermelon** is a super food: I eat lots of it (once it's not too sweet) because of the numerous benefits. It **cleanses toxins** from the body, has *anti-aging properties*. Eating watermelon before exercise helps cut recovery time and boost performance. It also **replaces electrolytes** and helps with **joint and muscle pain**.

3 **Get adequate rest:** *Sleep* plays an *important* role in your physical health. S*leep* is involved in healing and repair of your blood vessels and heart. Ongoing *sleep* deficiency is linked to an increased risk of heart disease, high blood pressure, kidney disease, diabetes, and stroke. Sleep helps your brain work properly. It also can affect how well you think, react, learn, work and get along with others. Getting enough quality sleep at the right times helps you function well throughout the day. Leaders who are sleep deficient are less productive. Studies also show that sleep deficiency alters activity in some parts of the brain. If you're sleep deficient, you may have trouble solving problems, making decisions, controlling your emotions and behaviour, and coping with change. Your immune system relies on sleep to stay healthy. Ongoing sleep deficiency can also change the way in which your immune system responds.

4 **Let go of negative emotions:** Holding on to negative emotions has been linked to many diseases. These will drain you and impede your thinking. Our body releases different chemicals when we experience various things that make us happy or angry and each chemical works to create a different environment within the body. The connection between your mind and body is very powerful and although it cannot be visually seen, the effects your mind can have on your physical body are profound. Anger, hatred, bitterness, resentment and worry are natural, but they are also some of the most toxic emotions that we can have. Prolonged bouts of these emotions can take the toll on the body in the form of high blood pressure, stress, anxiety, headaches and poor circulation. My formula is—focus on thinking good thoughts and practice gratitude, this always puts you in a good place in spite of the situation.

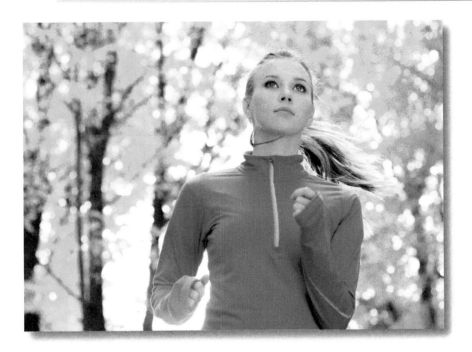

5 **Seek well-being:** According to New Economics Foundation (NEF), a British think tank, high in well-being means that you feel good about yourself and your life and enjoy what you do. Additionally, people high in well-being function well in the world by having positive relationships and a sense of control in their lives. It also incorporates having a sense of purpose in life. It's about fulfilment. Work-Life *Balance* is crucial. It is important to take time for yourself as well as engage in activities that will give you peace of mind such as having a hobby, playing a sport, taking part in outdoor activities, listening to music, having more social interactions, prayer, etc.

Furthermore, adopting a healthy lifestyle may not guarantee leadership success or a life free of medical complaints but it can definitely help you perform better in your leadership role which can increase your leadership longevity.

CHAPTER 16

Ten Leadership Lessons from Nature

Nature has a way of unfolding, which provides us with insights on how a leader can guide and direct an organization. Nature can be described as systematic, organized, and connected.

Therefore, looking at these characteristics, we can relate them to some sustainable organizations.

THUS, WE CAN LOOK TO NATURE TO LEARN SOME KEY LESSONS ABOUT LEADERSHIP:

Survival of the Fittest: According to science, that's what happens in the animal kingdom. Only those that have the ability to adapt and survive will live to pass on their genes. It's also called natural selection. Organizations that stand the test of time are those that promote growth through continuous learning, welcome challenges, and embrace failure for the opportunities it provides. Selection is key. In this regard, there must be efficient Human Resource practices for selection and training. Talented individuals with varying competencies and skills who can efficiently and effectively achieve the organization's goals and objectives should be chosen.

A Clear Vision: The leadership lesson drawn from the eagle is that of vision. This vision is sharp to the extent that it can capture objects from five kilometres in the air. When an eagle sights prey, it narrows its focus in pursuit until the prey is caught. Have a clear vision and remain focused no matter what obstacle is faced. Identifying and communicating a clear vision is one of the main functions a business leader can perform. Warren Bennis said, "Leadership is the capacity to translate vision into reality." "The very essence of leadership is that you have to have a vision. It's got to be a vision you articulate clearly and forcefully on every occasion. You can't blow an uncertain trumpet." —Theodore M. Hesburgh

Well Grounded: Trees have extensive root systems, and roots are the foundation of a healthy plant. The condition of a plant's root system has a profound effect on its overall health. While plants can tolerate a fair amount of damage to their upper parts, they are not nearly so forgiving of damage to their roots. It's important to have a *culture that is solidly embedded in ethical and other principles.* If the organization is to survive, leaders must be grounded in deep values that provide valuable guidance, especially when there is a dilemma faced in the decision-making process.

Change and Flexibility: Nothing remains constant. There is a season (winter, spring, summer, autumn) and time for everything. There is calm and then there is storm. Organizations go through different cycles, so always plan and be prepared. It's imperative to embrace change and take risks. Sometimes you have to shed your old bark (way of thinking) to grow. Good leaders also take into consideration the needs of their employees. You can't just have a system built on bureaucracy. Be flexible so you don't break when the harsh wind blows. The trees that bend a little to the moderate breeze will later grow to endure severe winds.

Teamwork: Work as a team to get the job done. You are effective if you work as a team to achieve a goal. Most people believe they already do a lot for the team. However, *research shows that most people are self-centric*, even if they believe otherwise. Ants focus more on the needs of the colony than their own individual needs. Working for the benefit of self can be detrimental to the overall performance of the team or the entire organization. If any of the ants are not working with the team, it will be noticed. The cohesion and teamwork determines whether the team lives or dies. Vista M. Kelly said, "Snowflakes are one of nature's most fragile things, but just look what they can do when they stick together."

Giving Back: Plants take in carbon dioxide and give back oxygen; trees are always giving back. They give energy, shade, shelter, fruits, and seeds. Even after they are dead they still contribute. Always *look at the big picture* to understand your place in the ecosystem. Learn everything you can about your department, your organization, and the marketplace.

Balance and Well Being: Nature promotes balance. It soothes, heals, and restores. Nature emphasizes the importance of rest, silence, and solitude. Healthy leaders adopt this philosophy in their lifestyle to ensure longevity. Robert Urich said, "A healthy outside starts from the inside."

Bearing Fruit: Are you sowing seeds that bear fruit? *What fruits are you bearing?* Fruit originates or comes from something. It is an effect, a result. By your fruits you are known. A good leader is hard at work preparing the soil, planting the seed, weeding, watering, and pruning to later reap a harvest. We produce what we are— our kind. What legacy are you leaving behind in others, in your team, and in the organization? Depending on your leadership style, you will bear lasting fruit, some fruit, diseased fruit, or no fruit.

Appreciation for Little Contributions: Leaves may seem insignificant, but they are critical to the life of a tree. Do not take members of your team for granted or show favouritism

to those whose roles seem far more important than others. The toes are just as necessary for the whole body to function effectively. Recognition and reward are important for building team morale. Just a simple thank you can indeed make all the difference, and they are the two most important words a leader can use.

Patience and Persistence: When it is time for the baby eagles to fly, they are patiently and persistently encouraged. Usually this process takes a couple of months. Good leaders patiently coach and support their team until they are ready to fly on their own. They also provide an environment that empowers and enables others to take on greater responsibility so that they, too, can develop into full-grown leaders (succession planning). Additionally, building a strong company takes time. Sam Walton, Wal-Mart founder, is quoted in *Good to Great*: "Somehow over the years people have gotten the impression that Wal-Mart was…just this great idea that turned into an overnight success. But…it was an outgrowth of everything we'd been doing since (1945)…And like most overnight successes, it was about twenty years in the making."

Leaders are responsible for achieving outcomes. Great leaders teach. **Great leaders help to develop and grow their teams**. Observing nature can allow us to learn leadership lessons in a different way that can contribute to a healthy organization.

The Ten Commandments of Effective Leadership

The term "law" evokes different mental images for each individual, whether positive or negative. However, the law is not just an external set of rules imposed on us. Without rules there

would be no life. For instance, if there were no laws governing traffic offences or criminal activities, what would take place? **An erosion of core values threatens both business and society at large**. A company will assume the standards and ethics of its leaders. Therefore, having a business leader with a strong moral compass is essential for success.

"To educate a man in mind and not in morals is to educate a menace to society." —Theodore Roosevelt

THE TEN COMMANDMENTS OF EFFECTIVE LEADERSHIP IDENTIFY THE CRITICAL PRINCIPLES FOR BEING A TRUSTED, RESPECTED, AND GREAT LEADER:

I. **Vision**: *Thou shalt walk by faith and not by sight.* Envision in your mind what you cannot see with your eyes. Stephen Covey posits all things are created twice. There is a mental (first) creation, and a physical (second) creation. The physical creation follows the mental, just as a building follows a blueprint. Great leaders have a clear vision of the desired direction and destination, and then work to make things happen. John F. Kennedy said, "Efforts and courage are not enough without purpose and direction."

II. **Authenticity**: *Thou shalt practice what you preach.* Authenticity acts as a catalyst that earns the respect of followers. The more your team trusts you, the easier they will follow your lead. Thomas Jefferson said, "I never did, or countenanced, in public life, a single act inconsistent with the strictest good faith; having never believed there was one code of morality for a public, and another for a private man."

III. Communication: *Thou shalt be quick to listen and slow to speak.* Great leaders listen twice as much as they speak. They listen with the intention of understanding. Listening can solve a host of problems, bring creativity, give insights, and show people that you care. Additionally, great leaders speak words of life to uplift others and never criticize or pull them down. They give constructive feedback. Andy Rooney said, "I've learned that one should keep his words both soft and tender, because tomorrow he may have to eat them."

IV. Integrity: *Thou shalt not covet, steal, or lie.* Leadership is not a right but a privilege bestowed upon the leader by followers. To whom much is given, much is required. Your decisions can negatively or positively affect the livelihood of others. Accountability is important for effective leadership. People seek to do business with people they know, like, and trust. A Japanese proverb states, "The reputation of a thousand years may be determined by the conduct of one hour."

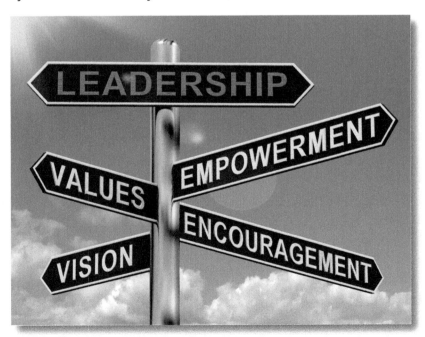

V. Humility: *Thou shalt strive to serve others.* Humility is a foundational leadership strength. True leaders always aim to serve rather than be served. Humble leaders use their power to empower others. They are able to genuinely relate to and empathize with their followers. They are aware of their own imperfections, so they forgive others' mistakes. They are flexible and are able to engage with others in ways that promote the overall good. They draw people by humility and honour, not by position and power. According to a study from the University of Washington Foster School of Business, humble people tend to make the most effective leaders.

VI. Gratitude: *Thou shalt give and it will be returned unto you.* Giving creates a boomerang effect. It's a universal law: the more you give, the more you receive. One does not function independently. It is essential to understand your place in industry and society, both locally and globally. Hoarding makes you like a stagnant pond. Instead, endeavour to be an ever-flowing fountain. Shakti Gawain said, "Our abilities to give and receive are at the core of our capacity to create and experience true prosperity."

VII. Balance and Well Being: *Thou shalt keep a day of rest.* Taking time for yourself is crucial to leadership. While leadership is about execution, getting things done, and action, it also requires time to unplug, reflect, and renew. Your effectiveness and longevity as a leader depend directly on finding and establishing regular periods to recharge. Alan Cohen stated, "There is virtue in work and there is virtue in rest. Use both and overlook neither."

VIII. Continuous Learning: *Thou shalt seek knowledge and wisdom.* Wisdom is fundamental to leadership existence.

Wisdom is the effective application of knowledge. Knowledge will only get you so far. It's wisdom that will give you the edge. Continuous self-growth and learning is the most effective way for leaders to survive competition and manage change. Great leaders know that leadership development is an ongoing process, so they are constantly looking for ways to improve themselves and their team. When one stops learning, it is a sure sign of decline in one's leadership status. "Wisdom is the principal thing; therefore get wisdom: and with all thy getting get understanding" (Proverbs 4:7).

IX. Inspiration: *Thou shalt lead the people through the wilderness to the promise land.* Inspirational leadership is about energizing and creating a sense of direction and purpose for followers and excitement and momentum to achieve goals. Inspirational leaders are capable of taking an organization and its people to new heights. Napoleon Bonaparte said, "A leader is a dealer in hope."

X. Reward and Recognition: *Thou shalt give honour unto whom it's due.* If employees feel their efforts and hard work aren't appreciated, they may get disgruntled. Great leaders openly praise their team and publicly acknowledge their contributions. They try to understand the source of motivation for their followers. Dale Carnegie said, "People work for money but go the extra mile for recognition, praise, and rewards."

"The measure of a man's real character is what he would do if he knew he would never be found out." —Thomas Babington Macaulay

These guiding principles should penetrate our motives, our secret intentions, and our lives. If one follows the law just

for outward display, this means nothing. The desire must be present within.

"If moral behaviour were simply following rules, we could program a computer to be moral." —Samuel P. Ginder

In the end, obedience can save us from learning things the hard way, as some consequences are more detrimental than others. *Sometimes instruction can and should be a better teacher than experience.*

CHAPTER 18

Life Lessons Successful Leaders Wish They Had Learned Earlier

"For wisdom is better than rubies; and all the things that may be desired are not to be compared to it." —Proverbs 8:11

"Wisdom is a good purchase, though we pay dearly for it." —Dutch proverb

$$W = f(T + E)^y$$

Wisdom is a function of Time and Experience

Wisdom is a function of **Time** and **Experience** to the power of You (**Individual factors**). Individual factors comprise aptitude, motivation, attitude, personality and cognitive style (the preferred way an individual processes information).

When climbing the ladder of success, we soon realize there are things we will have to learn on our own.

"We don't receive wisdom; we must discover it for ourselves after a journey that no one can take for us or spare us." — Marcel Proust

I would like to share some valuable life lessons from successful business leaders. I hope they will enlighten your path and prevent you from making the same mistakes. A wise person indeed learns from the successes as well as mistakes of others.

6 LIFE LESSONS SUCCESSFUL LEADERS WISH THEY HAD LEARNED EARLIER

TAKE CARE OF YOURSELF

"I wish I could go back and tell myself, 'Arianna, your performance will actually improve if you can commit to not only working hard, but also unplugging, recharging, and renewing yourself,'" said Arianna Huffington, President of the Huffington Post Media Group.

Stop wishing you had more time for yourself and commit to carving it into your schedule.

I had a close friend who worked non-stop. He was always "plugged in" and wouldn't even take vacation. He was diagnosed with cancer, took retirement, and died shortly thereafter. Sadly, though, he never got to enjoy any of his retirement earnings. Our bodies are not machines. You can't keep going 24/7. The lights won't always be green. If you don't slow down, sooner or later you will come to a red light and will have to make a complete stop. That's why it is important to eat healthy, exercise, drink lots of water, reduce stress levels, and get adequate rest. Furthermore, get rid of toxic emotions. Life is too short.

"Take care of your body. It's the only place you have to live."
—Jim Rohn

TAKE TIME TO LISTEN

Communication is a two-way street. Paul Bennett, the Chief Creative Officer at IDEO, said the one piece of advice he wished he had known in his early twenties was to *focus on listening*. Effective leaders learn that it is important to put aside distractions, to stop multi-tasking, and to be truly present with people when speaking with them. *Listening is a great time and money saver.* It can solve a host of problems, bring creativity, give insights, and show people that you care.

SURROUND YOURSELF WITH GREAT PEOPLE

Surround yourself with leaders in your field and be fearless in pursuit of game-changing ideas. Aim high and be ridiculously persistent. **Form alliances and strategic partnerships.** Seek out those who have traveled the path before and align yourself with those whose skills complement yours. Surround yourself with the movers and shakers.

"Whatever vocation you decide on, track down the best people in the world at doing it and surround yourself with them." —Scott Weiss, Partner at Andreessen Horowitz.

"Be fearless. Don't be afraid to pursue revolutionary ideas, and don't hold back simply because you're going up against seemingly unconquerable competitors in your market space. At Braintree, many of our competitors are huge, established companies in the market with market caps in the billions—but we're not afraid of going after them." —Bill Ready, CEO of Braintree.

DON'T LET MONEY DEFINE YOU: YOU DEFINE YOUR MONEY

"When you are starting out in your twenties, it is natural to think about all that you will have and do once you start making money, and making more money. That gives money way too much power over your life. It's not about how much you make, but the life that you make with the money you have." said Suze Orman, Author and Television host.

In the end, we have to accept these are all material possessions, and we can't take any of them with us when we leave this world. However, people will always remember your character and how you treated them, so spend some time developing priceless attributes such as integrity, honesty, empathy, and kindness.

GIVE BACK

"Ideally people can start to mix in some philanthropy like Mark Zuckerberg (CEO of Facebook) has early in his career. I have enjoyed talking to some of the entrepreneurs about this and I am impressed at how early they are thinking about giving back, much earlier than I did," —Bill Gates, Microsoft co-founder.

Those of us who are blessed with so much more should be thankful and seek to help the less fortunate. Giving not only benefits the receiver but also the giver. The fulfilment you get from helping someone else is incomparable. It's also a universal law. The more you give, the more you receive.

SPEND MORE TIME AWAY FROM THE OFFICE AND MORE TIME WITH FAMILY

David Kim, CEO of the investor consortium that operates chain restaurants, was motivated to succeed so he could support his parents. But at his father's deathbed, he revaluated his success and realized in his efforts to do everything for them, he missed a key point: precious time with them. "I regret not spending enough time with him, especially before he was going to go," he said. His epiphany led to him spending more time with his wife and children.

Wealth isn't all that many people consider it to be. Studies suggest that increasing income follows the **law of diminishing returns**. Beyond allowing people to buy more possessions and live comfortably, money cannot buy happiness. Meaningful relationships, helping others and a purposeful life make a greater contribution to one's happiness.

CHAPTER 19

How to Avoid the Human Rat Race

How do you stand out from the crowd when everyone is racing towards the same goals? How do shine brightly when there are already a million stars around?

HERE ARE MY SEVEN TIPS TO GET OTHERS TO STOP AND TAKE NOTICE OF YOU.

1 **Set Goals:** Stop procrastinating or wishing and start doing. Action fuels success. It's never too late to set new goals. Write them down. If you don't set goals you will be drifting aimlessly to wherever the wind takes you. You must form a plan. Eradicate time wasters. Have a clear road map to avoid going around in circles and to ensure you reach your destination in the most efficient and effective manner. I try to do at least two activities a week that will push me closer to achieving my goals. Even if it's a small step forward, it's still a step forward. If you aim at nothing, you will hit it every time. —Zig Ziglar

2 **Be Prepared to Work Hard:** There are no shortcuts in life. These all lead to dead ends. Sonia Choquette said, "The universe will fill your cup if you carry a big cup, a little cup, or a thimble." *Passion and persistence are key.* Most people say they want something but are not willing to make the necessary commitments to get it. Work hard but also work SMART. Learn the rules of the game and play it better than anyone else. Networking is crucial. Plan and strategize. I have made a lot of sacrifices and it has cost me a lot to get where I am today. "Ambition is the path to success. Persistence is the vehicle you arrive in." —Bill Bradley

3 **Be You:** Dare to be you, the real authentic you. It's okay to show your human side. Don't be a rat, be a person. Learn from others, but don't try to imitate them. You will be a poor replica. Be a voice, not an echo. "You were born an original. Don't die a copy." —John Mason.

Focus on your skills and talents. What you have to offer is incomparable and will definitely set you apart from the crowd. No one can play your role better than you. **Find your gift.** What is your core purpose? What is it you were given that no one else can do better? Allow your reason for being here to lead you to do the amazing things you were destined to do. Focus on your strengths and work on developing your shortfalls. Compromising the essence of who you are to find success can be likened to holding on to grains of sand. It will always slip through your fingers. Once you become who you truly are (self-mastery), you will make the most of this life that you have been given. I'm by nature very inspirational, so everything I do has my unique signature to it. *Embrace your distinctiveness.* Being a chameleon will get you lost in the crowd. "Don't compare yourself with anyone in this world ... if you do so you are insulting yourself," Bill Gates said.

4 **Take Risks:** "Sometimes you just have to jump out the window and grow wings on the way down." —Ray Bradbury. Embrace change and take advantage of opportunities that others overlook. *Go the extra mile. It is never crowded.* Ask for what you want. Be unconventional. Be disruptive. *In order to be successful, your focus has to be so intense that people call you crazy. Don't let fear hold you back.* Being a pioneer will definitely get you the attention of the masses. Most people set up shop in the comfort zone, then wonder why nothing is happening. Albert Einstein stated, "The one who follows the crowd will get no further than the crowd. The one who walks alone is likely to find himself in places no one has ever been."

5 **Keep Learning. Keep Growing:** Personal development is continuous. Learn everything about the field you are in. Become the expert others look to for advice. However, having

knowledge alone is not sufficient. What will set you apart is wisdom. I ask God daily for wisdom. Wisdom is the sensible application of knowledge. It is understanding, discretion, and discernment. It is a rare commodity. Wisdom is a fundamental principle to leadership existence. "To acquire knowledge, one must study; but to acquire wisdom, one must observe," said Marilyn vos Savant.

6 **Add Value:** Forget the cheese; go for significance. Novelist James Matthew Brice said, "Those who bring sunshine to the lives of others cannot keep it from themselves." Whatever I do, I always seek to make a positive contribution. Whatever you put your hands to, from the simplest to the greatest of tasks, do it with all your might. Strive for excellence. Money should not be your sole motivator. Research shows that most people are self-centric, even if they believe otherwise. Flip the card over and don't just ask what you can get, but ask also what you can give. The rat race is never ending. It sucks you in and has its grip fixed so tightly that you forget to enjoy the journey and those around you. Life is full of moving targets. The bar is constantly being set higher and higher.

7 **Enjoy the Journey:** Breathe! Life is not a 100 metre sprint but a long distance race. Prioritize, it's important to take time to stop and smell the roses. Take breaks. Spend time with those closest to you. Show them how much you appreciate them. **These are special moments that once you miss may not come around again**. Additionally, don't wait for huge victories, celebrate small successes. "*Take pride* in how far you've come. Have faith in how far you can go. But don't forget to enjoy the journey." —Michael Josephson

FIVE QUESTIONS TO BRING CLARITY

- ➲ What happens after you have won the coveted prize? Do you leave it on the shelf to collect dust and rush after the next one?

- ➲ Does your reward give you satisfaction and fulfilment?

- ➲ Is the price you are paying (health, family, time, peace of mind) far too steep? Is it really worth it in the end?

- ➲ What is your purpose? What is your ultimate goal?

- ➲ What do you really want?

WHAT CONSUMES YOUR MIND CONTROLS YOUR LIFE. WHAT'S ON YOUR MIND?

Turn the hamster wheel faster than anyone else and all you'll do is end up exhausted and frustrated. The wheel just keeps spinning.

"Most people don't live; they just race. They are trying to reach some goal far away on the horizon, and in the heat of the going they get so breathless and panting that they lose sight of the beautiful, tranquil country they are passing through . . ." —Jean Webster

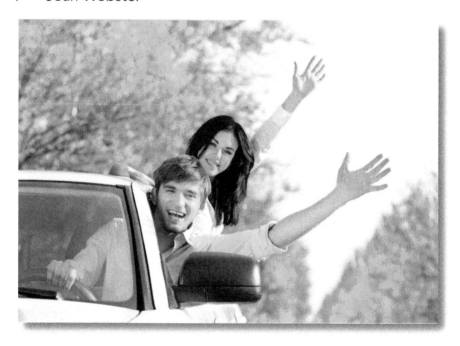

Maybe it's time for you to redefine success and the criteria for winning. Enter the race you are designed to run. **Run your own race.** Gauge the course and **run at your own pace.** Don't look to the left or right, to see how others are doing.

Look straight ahead to the finish line. **Focus on beating your personal best**. It's important not to compare yourself to anyone. Sometimes it may appear others are progressing faster than you. Don't worry if others overlap you. There is a season and time for everything. Have patience, your time will come. We all achieve milestones at different points. Someone may have accomplished goals in their 20s, whilst it took you in your 40s to do the same. That is okay, this is the lot you were given and you did the best with it. **Be at peace with yourself** and where you are.

"I am in competition with no one. I have no desire to play the game of being better than anyone. I am simply trying to be better than the person I was *yesterday*." —Unknown

I run for a higher purpose. I teach a free financial planning course in my community. Most of the attendees are from poor circumstances with minimal educational. My greatest joy comes at the end from hearing the words "you have helped me."

If you are caught on the wheel you must take responsibility and the initiative to change. **Help others along the way**. When you lead, call those you lead to a higher purpose, and you'll bring out the best in yourself and others. True success can be found in our quiet selfless service to others. Only by using your gifts and talents in the service of others can you win a life that brings lasting fulfilment.

"The trouble with the rat race is that even if you win, you're still a rat." —Lily Tomlin

The Memorable Leader

The true test of your leadership comes after you have gone. Do you remain in the hearts of your followers? Is the baton passed on to follow the vision, or does it die with you? We see people who are still being inspired by the world's greatest

leaders. Their influence seems to be strengthened in their absence. I lost one of my managers a couple of years ago, and I can't seem to forget him or the legacy he left behind. Sometimes, I browse through saved emails from him and think of how awesome a person he was.

FIVE COMMON QUALITIES OF MEMORABLE LEADERS

1 **Integrity and Authenticity:** These go hand in hand. Great leaders are known for the ethical principles they stand on, and their actions promote these values. Joseph, my manager, was honest with employees even though this trait was sometimes unpopular with top management. He often took the slack for his team. If leadership is not authentic, then what is it? Authenticity acts as a catalyst that earns the respect of employees. Authenticity builds trust, and followers love leaders they can trust.

"The supreme quality for leadership is unquestionably integrity." —Dwight D. Eisenhower.

"In all my research, the greatest leaders looked inward and were able to tell a good story with authenticity and passion." —Deepak Chopra

2 **Humility:** This is a critical leadership success factor. Leading with humility means focusing on others and practicing the servant leadership. *True leaders always aim to serve rather than be served.* Being humble makes you more approachable to your followers and allows you to create an environment of open communication and more effective feedback. A true

leader is one who is humble enough to admit mistakes. They are not afraid to seek assistance or admit that they don't know. Leaders that share the credit for problems and don't blame others are more respected by their team.

"The x factor of great leadership is not personality, its humility." —Jim Collins, business management expert

3 **Empathy:** Empathy plays a critical role in one's ability to be a successful leader, sharpens your people acumen, and informs your decisions. We tend to confuse empathy with sympathy; however, empathy is really being able to understand the needs of others. It means that you are aware of their feelings and how they impact their perception. Empathy is an important component of effective relationships and is indeed a valued currency. Empathy allows leaders to develop and maintain relationships with those they lead. Leaders that possess this trait always make time for people. Many organizations are focused on achieving goals no matter what the cost to employees. Great leaders are concerned about getting the job done as well as the well-being of those under their care. They are supportive of their employees' development.

"Empathy is about standing in someone else's shoes, feeling with his or her heart, seeing with his or her eyes. Not only is empathy hard to outsource and automate, but it makes the world a better place." —Daniel H. Pink

4 **Communication:** Leadership has been described as a process of social influence in which a person can enlist the aid and support of others in the accomplishment of a common goal. Therefore, two way communication is key to leadership success. Great leaders are able to communicate their vision in such a way that it motivates their team. They are great

communicators: quick to listen and slow to speak. They possess high emotional intelligence skills. They value and often ask for their team's input.

"If you want to build a ship, don't drum up the men to gather wood, divide the work, and give orders. Instead, teach them to yearn for the vast and endless sea." —Antoine de Saint-Exupery

5 **Inspiration:** Inspirational leadership is about energizing and creating a sense of direction and purpose for employees and excitement and momentum to achieve goals. Inspirational leaders are capable of taking an organization and people to new heights. They are able to get followers, even those without a title, to do tasks. They recognize individual achievements and knowledge and capabilities, and they openly praise their employees. Joseph taught me to believe in myself and saw qualities in me I didn't know I had. Words he used often were "good work team," "you are the best," "I trust your judgment," and "well done," and using these words made team spirit high during his reign. He made everyone feel valued and appreciated. The greatest legacy a leader can leave is having developed other leaders. If you want to leave a legacy, invest in people.

"If your actions inspire others to dream more, learn more, do more, and become more, you are a leader." —John Quincy Adams

I can still picture Joseph walking through the office greeting staff some mornings and even giving me a little nod or pat on the back. Those were the special moments I still hold dear. It doesn't take much to create those special moments with your team; it's the little things that you do that count the most.

"I've learned that people will forget what you said, people will forget what you did, but people will never forget how you made them feel." —Maya Angelou

Whether you want to admit it or not, you are making or leaving a mark. Making a mark is likened to leaving footprints in the sand; whereas, leaving a mark is one which is embedded in stone. I'm referring to unforgettable positive impressions.

If **you value people, everything else will fall into place**. "People are what matter in this world—not money or fame or buildings or organizations or institutions. Only people." — John C. Maxwell.

What legacy are you leaving behind?

Part Five

PERSONAL DEVELOPMENT

Full Body Leadership
Medical Evaluation

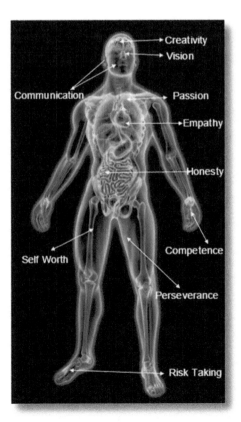

When was the last time you stopped to take a full body leadership medical examination? This is absolutely crucial for diagnosing existing ailments and acts as a preventative measure for discovering other conditions in their early stages.

It is imperative that you first seek a physician consultation. Do you have a mentor or coach? Early detection is key. Leadership can be stressful at times. How well do you handle the dissenting voices? Do you crumble under pressure? To begin with, you will be required to undergo a blood test to determine your blood type and pressure. If your blood type is "Be Positive" (B+) and your pressure is normal, this a great starting point.

DEPENDING ON THE RESULTS OF YOUR CONSULTATION (MRI OR CT SCAN), THE FOLLOWING TEN EXAMINATIONS COULD BE RECOMMENDED.

1 **Pulmonary Function Test:** The cells of the human body require a constant stream of oxygen to stay alive. The respiratory system provides oxygen to the body's cells. Do you breathe *passion and purpose*? Passion is the breath of life. Lack of passion is fatal. *Passion* is an intense emotion, compelling enthusiasm, or desire for something. It's the fire that burns within. Is your fire still burning bright or has it gone dim?

"Passion is oxygen of the soul." —Bill Butler

2 **Electrocardiogram (ECG):** The heart represents the seat of emotions. Do you display *empathy*, *compassion*, and *authenticity*? Leaders with empathy use their knowledge to improve their companies in subtle but important ways. This

doesn't mean that they agree with everyone's view or try to please everybody.

"Empathy means thoughtfully considering employee's feelings, along with other factors, in the process of making intelligent decisions." —Dr. Daniel Goleman

3 **Brain Intelligence Test (IQ):** Do you think outside the box? Do you surround yourself with smart, passionate, and competent individuals? An essential aspect of creativity is not being afraid to fail. It's important to build a strong team and welcome fresh opinions, perspectives, and honest feedback. *Creativity and innovation are the lifeblood* of any organization.

"If we do not employ creativity as a core cultural imperative in business, we will be stuck in yesterday's success." —Erik Wahl

4 **Ultrasound of Abdomen:** The function of the intestines is to digest food and to enable the nutrients released from that food to enter into the bloodstream. Does truth reside in your inward parts? *Do honesty and integrity run through your veins?* A leader needs to be trusted and be known for living by ethical principles.

5 **Speech and Hearing Assessment:** Is your speech seasoned with salt? Do you practice passive, active listening or intuitive listening? Intuitive listening is being receptive by paying attention to the meaning behind the speaker's words. A good leader is a good listener. Developing excellent communication skills is absolutely essential to effective leadership. "If a leader can't get a message across clearly and motivate others to act on it, then having a message doesn't even matter." —Gilbert Amelio. **Emotional Intelligence (relational wellness):** Emotional intelligence (EQ) plays a big part in effective communication.

You may be also required to take this test which is a subset. Leaders possessing high EQ are able to communicate more effectively and, therefore, influence and inspire others.

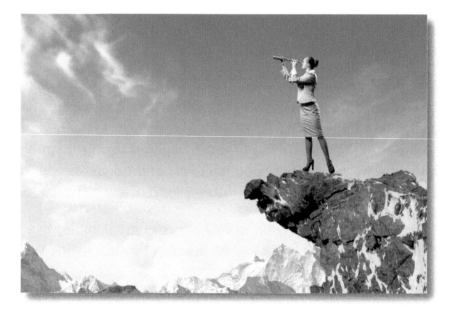

6 **Comprehensive Eye Exam:** This test is crucial to avoid the classic "blind leading the blind" syndrome. Do you have sight or vision? Sight is confined to your current environment, while vision sees your future possibilities. Great leaders understand the power of vision, and they capitalize on it by painting a clear vision of the future. Having good vision is necessary to keeping you on track. It illuminates the whole body and serves as a beacon to your employees.

7 **Rheumatoid Factor Test:** Arthritis can cause joint pain and stiffness in your hands and may greatly affect your ability to complete simple tasks.

"Competence goes beyond words. It's the leader's ability to say it, plan it, and do it in such a way that others know that you

know how—and know that they want to follow you." —John. C. Maxwell

8 **Blood Glucose Test:** If you have diabetes, your feet are vulnerable to a variety of problems. Do you prefer "sweet" settings and stay in your comfort zone? Are you a risk taker? Do you embrace change?

"Do not go where the path may lead, go instead where there is no path and leave a trail." —Ralph Waldo Emerson

9 **Muscle Strength, Endurance, and Flexibility Test:** Muscles are the engine that your body uses to propel itself. It would be impossible for you to do anything without your muscles. Having perseverance means building muscle, and to do that you will have to complete the **Ironman Leadership Triathlon**: swim through failure, jump over rejection, and climb over obstacles.

"Perseverance is not a long race; it is many short races one after the other." —Walter Elliott

10 **Skeletal X-Ray:** The skeletal system provides the framework to which all other tissues and organs attach, giving shape to the human body. Where do you get your self-worth? Do you separate who you are from what you do? Many leaders lose their sense of self-identity in their leadership function and depend on their title to define them.

Acceptance and admittance is fundamental to dealing with unwholesome leadership. **Depending on your diagnosis the following may be proposed:**

⮑ **Body cleanse.** Harbouring toxic emotions can lead to a build-up of harmful pathogens which can thwart

your thought and problem-solving process. If you have been burned (betrayed) just apply ice. It's also important to undergo a detoxification programme to flush the body of viruses thus ensuring proper pH (acid-alkaline) balance. To maintain equilibrium you will be administered an injection of *Life Lessons that Successful Leaders wished they had learned Earlier* (Chapter 18).

➲ **Exercise coupled with diet counselling** is important if you have lifestyle diseases. A healthy diet will build up your body and sustain your strength. Remember to drink plenty of water and other fluids to stay hydrated. The temperature at the top can sometimes soar to record highs, you don't want to get heat stroke. Additionally, if your daily nutritional intake is insufficient, you may require an additional vitamin and mineral supplement–*The Three Pills Every Leader Should Take* (Chapter 22).

➲ **Electric shock** by a defibrillator (employee surveys) may be required if your leadership has flat lined to wake you up to reality. You then will be transported to the operating theatre to view–*How to Motivate Your Employees in Ten Easy Steps* (Chapter 12).

Consequently, if you do not heed the physician's coaching, this can be very costly to the company (reduction in revenue). By not taking prescribed medication your condition can become life threatening, which can abruptly conclude your leadership presence. Therefore, placing a pint-sized adhesive bandage on a severe infection is pointless. You will have to go under the knife (surgery). Surgical removal of negative behaviours is essential to stop them from spreading. It can be painful, but it will help you to become a leader that is **fit to lead yourself and others.**

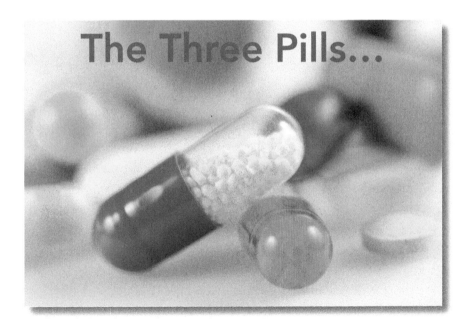

CHAPTER 22

The Three Pills Every Leader Should Take

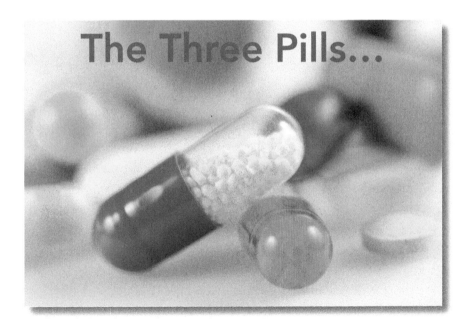

The Three Pills...

A healthy diet consisting of communication, confidence, intelligence, and integrity is great, but may not be sufficient for effective leadership. Specific conditions may result in a greater

need for certain nutrients. Nutrient deficiencies invariably lead to serious health problems.

That's why supplements of *Stillness, Silence,* **and** *Solitude* should be added to your diet to make up for shortfalls. As you go to higher altitudes, your ability to absorb crucial information decreases due to increased pressure, noise, and demands. The environment is completely different at high altitude compared to that at sea level. The view is marvellous from a high summit, but traveling at this height requires increased caution.

THE FOLLOWING THREE CAPSULES AID IN THE PREVENTION OF DEGENERATIVE DISEASES THAT CAN CURTAIL YOUR LEADERSHIP LIFE-SPAN, AND CREATE AN ENVIRONMENT CONDUCIVE TO PEAK PERFORMANCE.

1 Stillness

Silence cures unbridled enthusiasm. When was the last time you stopped or paused: no meetings, no phone ringing, just stillness? Stillness allows for information to be absorbed and will give you a chance to focus. The competition may be steep and the market ever evolving, but effective leaders know they have to get it together and focus.

"A wise woodcutter indeed is he who rather than constantly chopping wood will occasionally stop to sharpen his axe." — Unknown

Leaders that can appreciate the value of stillness can move forward and sustain momentum after pausing.

"I insist on a lot of time being spent, almost every day, to just sit and think. That is very uncommon in American business. I read and think. So I do more reading and thinking, and make less impulse decisions than most people in business."
—Warren Buffet

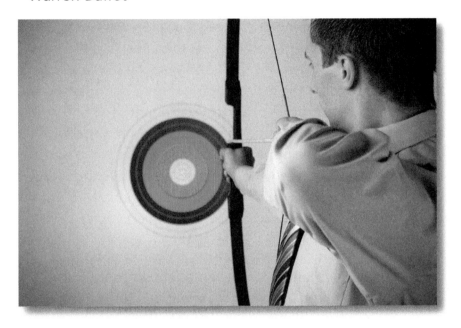

During Amazon's early years, Jeff Bezos, founder and CEO, made many mistakes. In 1998 he ventured into the toy market (and spent $120 million), which proved unsuccessful. In the same year, he started Amazon Auctions (and spent $175 million). This was a bigger failure than the toy market investment. Another 1998 purchase was Junglee (on which he spent $170 million), which also failed. Bezos dreamed of Amazon selling everything in the world and went on a huge shopping spree in 1998 and 1999, acquiring and investing in a number of companies. Almost all of them failed. He had close to a billion dollars in failures. However, by 2000 he paused

acquisitions and focused on the company's core business model and was able to make better decisions.

2 Silence

Silence cures foot in the mouth disease and can be divided between saying nothing and wisely picking your words. Emily Dickinson said, "Saying nothing … sometimes says the most." Silence can be a powerful tool. Today many leaders talk far too much and listen too little, when it should be the other way around. The words you speak to your employees and to the watching world defines you. With technology and social media you can't utter anything in secret. Your words will be cast in stone. Furthermore, many people are so sensitive today that a simple joke can land you in hot water. Additionally, there are those who are just waiting to twist everything you say.

Silence is especially important when negotiations are going nowhere. Silence can be an effective tool to stop the conversation and get everyone to reflect on what is happening.

When you or someone else is angry, silence allows for emotions to settle.

When you want to learn more, not talking and listening is the best way to learn information.

Silence is awkward for most people, as they instinctively want to fill in the blank space.

"The right word may be effective, but no word was ever as effective as a rightly timed pause." —Mark Twain

When it comes to a company's reputation, sometimes top executives are their own worst enemy. Lululemon's founder Chip Wilson set the Web on fire with his distasteful comments on customers' thighs during an appearance on Bloomberg's "Street Smart." Abbey Klaassen, executive editor of *Advertising Age*, said Lululemon's brand had been damaged. "He insulted his customers, which is a big problem." After Wilson's remarks, the company's share prices plummeted nearly 4 percent, and the company had to readjust sales expectations. His apology came three days after the television interview but did little to soothe the damage that had already been done.

"It is not so much what we say as much as what is in our heart when we say it." — Rosilind Jukic

3 Solitude

Solitude cures chronic burnout. Taking time for yourself is crucial to leadership. While leadership is about execution, getting things done, and action, it also requires time to pause and reflect. Solitude is one of the most important necessities of true leadership. It's a time of rest, peace, strengthening, and refreshment. Distancing oneself from distractions and taking the time to listen to your thoughts is the path to wisdom.

"The best thinking has been done in solitude." —Thomas Edison

Your effectiveness and maybe even your longevity as a leader depend directly on finding and establishing regular periods of solitude. William Deresiewicz posits that our tech-saturated lives result in too much multitasking, when we really need to spend time working through our questions and doubts and formulating our own ideas away from the cacophony of voices that surround us.

When we look at the world's major religions, there is a recurring story where leaders go off alone, apart from the crowd, to pray and connect with God. Solitude promotes reflection and introspection, which are incredibly powerful leadership tools for enhancing clarity and vision in problem solving.

HERE ARE THREE WAYS BUSY LEADERS CARVE OUT SOLITUDE:

- ➲ **Get up earlier.** Starting your day earlier gives you the stillness that would otherwise elude you for the rest of the day. Christie's CEO Steven Murphy gets up quite early to think. Thinking and planning in the morning, according to him, makes him strategic and proactive, rather than reactive.

- ➲ **Schedule nothing on your calendar.** Jeff Weiner, CEO of LinkedIn, schedules thirty- to ninety-minute blocks of doing nothing into his schedule. Weiner says, ". . . It's a system I developed over the last several years in response to a schedule that was becoming so jammed with back-to-back meetings that I had little time left to process what was going on around me or just think."

- ➲ **Take a break.** Put your phone on silent even if it's just for five minutes, and allow yourself to breathe. "Every day after lunch, I lie down on the sofa in my office, I hold my car keys in my right hand, and let my hand hang toward the floor. When the car keys fall out of my hand, I know I'm done," said Sam Moore, former CEO of Thomas Nelson Publishers.

"It is only through silence and stillness that we can come to our thoughts in any meaningful way and from that spring take action we think best. Sadly we have banished solitude. There is no time to think, alone, intimately with who we are at our core." —Brian Tolle Partner, The Re-Wired Group

We all have genetic weaknesses, including higher needs of some nutrients, higher rates of depletion for certain nutrients,

and an increased likelihood of genetic expression of some illnesses if vitamin or mineral deficiencies are present. These supplements enrich the body's internal environment to support repair, regeneration, and the renewal process. However, **overdosing on any of these three pills will have detrimental side effects**. Discernment is key. It's important to know the prescribed doses to apply in any given scenario.

Don't Fall into these Leadership Traps

Two in five CEOs fail within their first eighteen months of leading an organization, according to a study published in the

Harvard Business Review. One-third of chief executives from Fortune 500 companies don't make it past three years.

Achieving goals requires your team's support and commitment. If your team is not on board, this could lead to you being unsuccessful in your leadership role.

HERE ARE FOUR OF THE MOST COMMON PITFALLS THAT CAN CAST YOU IN A NEGATIVE LIGHT AND "TURN OFF" YOUR EMPLOYEES, THEREBY RENDERING YOUR LEADERSHIP INEFFECTIVE.

THE "MARIONETTE" TRAP

The challenge for any leader is working within predefined parameters, yet being able to apply your own talents to achieve results. In an age of uncertainty, many leaders are yielding to this trap of just playing it safe to preserve their position and privileges. The sad part is your employees are listening and seeing everything and are murmuring behind your back. *If you have to be continuously directed, you are, in fact, a puppet.*

I know of some boards who only hire managers that they can control. If your only concern is to impress top management, you will lose points with your employees. There must be a balance. You want to impress those at the top, but what about your employees? In the end no one takes you seriously, neither the board you are trying to impress nor the employees you have ignored.

Stanley Milgram (1963), a psychologist at Yale University, conducted research (shock experiment) focusing on the conflict between obedience to authority and personal conscience. He was interested in determining how far people would go in obeying an instruction, if it involved hurting another person. The results were alarming as most of the participants (65 percent), were willing to inflict pain on another person, simply because they were ordered to. He concluded that obedience is so ingrained, that people tend to obey orders from individuals who are in positions of authority over them, even if they violate their own morals and ethics.

"Ordinary people, simply doing their jobs, and without any particular hostility on their part, can become agents in a terrible destructive process." —Stanley Milgram (1974)

THE "KING KONG" TRAP

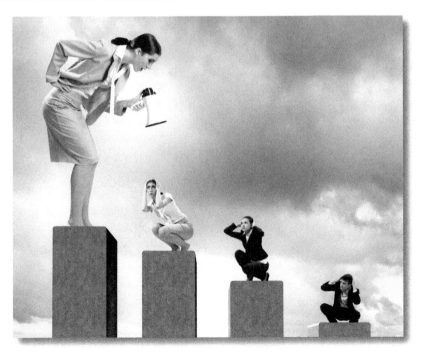

When some leaders reach the top, they immediately forget where they came from. Great leaders don't talk down to staff or make them feel inferior. Respect is a must. Show respect for all those you come in contact with, not just your employees, inclusive of the kitchen attendant, the janitor, the security guard, and anyone else. Your in-house reputation will quickly spread.

At NCR Corp, company revenues grew to $6.2 billion in 2013 from $6.0 billion in 2012, yet employees showed a strong dislike for their CEO, Bill Nuti. One employee wrote to upper management, "We carry your water every day, and you disrespect us every day, we're just your minions. You put out surveys, obviously you pay no attention to them or things would begin changing."

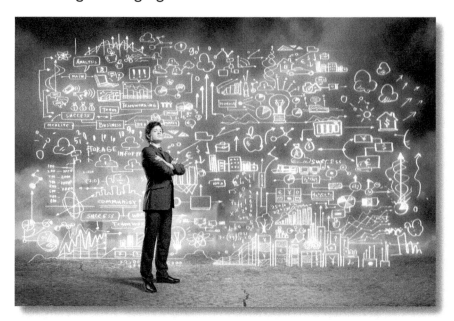

THE "SUPERMAN" TRAP

This includes making all decisions solo, ignoring feedback you don't like, and becoming isolated. Letting your ego get ahead of you and thinking you know it all is a sure path to failure. Use collaborative skills to arrive at solutions. Admit when you don't know. Showing some vulnerability allows you to strengthen relations with your team. You'll build trust more easily.

George Shaheen, former CEO at Webvan.com, joined Webvan in September 1999. He thought of himself as one of the greatest business consultants in the world when he ran Andersen. Yet, it seems he did nothing to effectively review Webvan's business model. He made no effort to work with the board of directors or management to alter the company's operations, and he made a series of bad decisions that led to Webvan declaring bankruptcy in 2001.

THE "TASKMASTER" TRAP

Do you brush over your team's successes with a bland acknowledgement while automatically working towards the next goal? Are results your only motivator? Continuously drilling employees is a sure way to lose points. If you ignore the wins of your team, you miss a vital opportunity to not only inspire but to build a more personal connection with your team, which can give your leadership personal brand a boost.

Many leaders don't stop to celebrate their small successes. One notable exception is Richard Branson who, at the Virgin Group, integrates work and play and has shared his thoughts

on how to make employees happy: "Don't forget to celebrate achievements and have some fun while doing so."

Falling into any one of these traps can result in disastrous consequences. **It's difficult to see yourself as others see you.** The challenge is to recognize these traps as they definitely can hurt your personal leadership brand. It's important to do some introspection. If you find yourself guilty of any of these, just adjust the sails accordingly.

CHAPTER 24

Seven Deadly Sins
of Leadership

Leadership is not as easy as it seems. Being at the forefront of the multitude makes you an instant target. The temptations are numerous and can be overwhelming. You don't have to search for them; they will come straight to your doorstep. If any leeway is given, they will find their way in. Standing on the mountaintop can make one think one is invincible. However, too many leaders at the pinnacle of success are failing due to foolish mistakes.

MORE EMPHASIS NEEDS TO BE PLACED ON AVOIDING THESE IMPROPRIETIES, WHICH CAN ABBREVIATE SUCCESS.

1 **Lust:** The battle begins in the mind. You are what you feed yourself. Forbidden fruit may taste sweet, but it has bitter consequences. Discipline and self-control are crucial. Today you can't pick up the newspaper without reading about some politician or public or prominent figure of society succumbing to this vice. Cherishing lust will erode your reasoning and cloud your judgement. Think before you act! I can't say this enough. Ask yourself if it's really worth it. Can you play with fire and not get burned? If it's too good to be true, then it probably is. Some pay for this more than others.

Google executive Forrest Hayes (fifty-one years old), abandoned by a high-end call girl as he lay dying of a drug overdose, was found dead in the cabin of his luxury yacht. Security camera footage shows her stepping over Hayes's body to finish a glass of wine while he lay unconscious, making no attempt to help him. Hayes was a married father of five and previously held senior roles at Sun Microsystems and Apple. Co-workers praised his professionalism and work ethic:

"You showed us how to be better engineers and a better team."

"Your impact and focus was tremendous, but your touch for inspiring those around you is what made you an incredible leader."

2 **Pride:** The ego must go. It's not about you. *Build a strong team* and surround yourself with smart, passionate, and highly competent people. *Developing leadership skills is a lifetime project.* It's too easy, as a leader, to feel like you have to be the one who knows everything. Great leaders recognize that they need to keep learning. Additionally, *treat everyone with respect* at all times whether they are employees, customers, suppliers, or partners. *Be humble.* The more humble you remain, the more subordinates will be motivated to share their suggestions and recommendations with you. *The greater your success, the more you need to stay in touch with fresh opinions and perspectives and welcome honest feedback.*

Microsoft's Steve Ballmer constructed his own private bubble. He was passionate in his belief that so long as he said it, it could and would be done. Furthermore, he was convinced that so long as he vociferously denounced any competing product or service that would be the end of it. Steve Ballmer's Windows 8 strategies created media scorn, investor derision, and relatively few happy customers. Microsoft began losing its dominance in the software industry. Under Ballmer, Microsoft's stock slumped, losing 44 percent during his tenure.

3 **Sloth:** Get rid of complacency. Embrace change. Be adaptable. Consumer needs and the marketplace are ever evolving. The global playing field has levelled. As a result of continuous technology acceleration, the change is rapid, inevitable, and unstoppable. *Listen to what your customers and employees are saying and go back to the drawing board.*

I remember once making a recommendation to a boss and being told thanks but no thanks: "This is how we have always done things and we will continue to do it this way."

BlackBerry: Research with no motion. In a board meeting, Mike Lazaridis, the BlackBerry co-founder and former chief executive, pointed to a BlackBerry. "I get this," he said. "It's clearly differentiated." Then he pointed to a touchscreen phone. "I don't get this."

To turn away from a product that has always done well with corporate customers and focus on selling yet another all-touch smartphone in a market crowded with them was a huge mistake, Lazaridis warned his fellow directors. Some of them agreed. Success had come almost naturally to BlackBerry until Apple released the first iPhone and upended their long-held strategy of appealing primarily to email-addicted professionals.

4 **Greed:** Greed and dishonesty go hand in hand. Reputation, integrity, and credibility are everything. Your reputation, whether good or bad, will spread faster than a viral video. Once lost, it is extremely difficult to regain. Keep pinching the cookie and, before long, you will be grabbing by the handful. I often say that dishonesty is like digging a deep hole for yourself. You can never control the depth of the consequences. When I was very young, I stole a snack from the village shop, and my mother gave me a good spanking. I can never forget her words: "You must not touch what is not yours!" Those words are embedded in my mind-set. Even if you are not caught, you will be forfeiting peace of mind, as you have to be constantly looking over your shoulder.

The death of the fifty-seven-year-old banker Richard Talley, CEO of Denver-based American Title Services (ATS), was

accompanied by the fact that his firm was under investigation by insurance regulators. Prosecutors had launched a criminal investigation for over $2 million missing from escrow accounts. Talley committed suicide. Police found him dressed for work, sitting in his car. Records show Talley was to be confronted about the missing escrow funds the morning he died. ATS filed for bankruptcy liquidation shortly after Talley's suicide.

5 **Envy: If you don't control your emotions, they will control you.** Envy is like a consuming vine and can lead to resentment and bitterness. It can reduce once rational people to insane behaviour and create executive infighting and power struggles. Choose to live beyond your emotions.

Public fallout started for Hewlett-Packard with the bitter infighting over HP's merger with Compaq in 2002, which reached its lowest point when the company's high-profile CEO, Carly Fiorina, ridiculed Walter Hewlett, a board member and son of a company founder, for daring to voice his opposition. The board was riven by feuds and so out of control that some directors were leaking secrets to the press while the chairman of the board was hiring private investigators to obtain phone records to uncover the perpetrators. This saw the rise and sudden resignation of former chief executive Mark Hurd.

6 **Wrath:** Wrath is a powerful emotion. When it gets out of control it can turn destructive. It impairs your judgment, has a negative impact on the way people see you (destroys relationships), and often gets in the way of success. "A patient man has great understanding, but a quick-tempered man displays folly" (Proverbs 14:29).

AOL's CEO Tim Armstrong's inordinate and uncontrolled anger resulted in the impulsive firing of an employee for taking his

picture. This took place at a company meeting and was done in front of a thousand employees. He was later forced to make a public apology. However, by then the damage had already been done because he had lost the respect of most of his team.

7 **Gluttony:** "Temperance: Eat not to dullness; drink not to elevation," said Benjamin Franklin.

It seems the more we have, the more we want. Who can satisfy an appetite that can never be filled? Successful leaders are able to discipline themselves and show self-restraint. Frank Herbert said, "The proximity of a desirable thing tempts one to overindulgence. On that path lies danger."

Dennis Kozlowski, former chief executive of Tyco International Ltd., was one of America's best paid corporate executives. He regularly reached into Tyco coffers to finance his extravagant lifestyle. Kozlowski went on a spending spree and purchased a Monet painting for $4 million, hosted a $2 million party for his second wife's fortieth birthday, and bought a $6,000 *shower curtain*. He transferred massive sums of money to himself at the expense of shareholders to gratify his lavish tastes. Kozlowski resigned in June 2002, a day before being indicted on charges that he evaded New York sales taxes on pricey works of art.

These lessons need to be revisited over and over and taught to seasoned as well as upcoming leaders. Don't think you cannot be susceptible. Even those who should know better are succumbing to these vices. It's important to set your standards early on. Take heed. Compromise a little here and there and before you know it, the tree of stained character is full-grown.

Always have your head in the right place. There are no shortcuts to any place worth going. Most individuals don't start out being unethical. It's so sad how much hard work, time, and effort these individuals invest to reach where they are, then blithely trade it for a gold-plated dime.

This takes me back to the story of the Trojan War and the Fall of Troy. The moral of the story: "Above all else, guard your heart; for out of it flows the issues of life" (Proverbs 4:23).

CHAPTER 25

Authentic Leadership: Who's Behind the Mask?

Authenticity is one of the most essential and admired leadership traits; however, in today's world it seems to be lacking. **What you see is not often what you get**. The masquerade mask

became a symbol in the seventeenth century. It was the key accessory at a masquerade ball. It made everyone look equal, and it allowed attendees to be whoever they wanted to be for one night. It embodied delusion and deceit. Today, in the twenty-first century, it seems to have made a comeback at the Leadership Ball.

The ancient Greek philosopher Diogenes (fourth century B.C.) of the Socratic period is considered as one of the founders of the ancient Greek philosophical school of Cynicism. According to legend, he would walk around the marketplace in daytime, claiming he was looking for an **honest man**.

Leaders wear masks for three main reasons:

- ⮑ To hide their true identity
- ⮑ To conceal insecurities
- ⮑ To take on a new persona that they feel is necessary for success.

Wearing masks undermines trust and effectiveness.

SEVEN MASKS SOME LEADERS WEAR

1 **Orator (Two-faced mask)**: Double tongued are they—great communicators (or more like great deceivers). They can sound so persuasive, so caring, and so sincere. Fervent lips which sound so eloquent can hide their true character. Behind the dazzling mask lies their real intention: deception. Erroneous communications are a big cause of lack of perceived trustworthiness in bosses. Politicians are notorious and highly populate this category. However, their actions always expose

them. We don't take them at face value because we don't know which face they have on.

2 **Advocate (Three Musketeers mask):** All for one and one for one. They are all for me, myself, and I. The love of money and power is their main motivator. They outwardly proclaim they are focused and that their priority is the team, but behind closed doors they are self-seeking, and when the opportunity is presented to prove it, they cannot. They will do anything to make themselves look good or maintain their status quo even at the expense of the team.

3 **Philanthropist (Robin Hood mask):** They give with the right hand but secretly take back with the left hand. Under this disguise, these leaders give openly so others can think highly of them. If there was no fanfare, they would not support charitable initiatives. Former Tyco International Ltd. chairman Dennis Kozlowski improperly used company funds to promote himself as a generous benefactor. He committed more than $100 million of the conglomerate's money to good causes; however, his own foundation gave little to charity. He was accused of stealing $134 million from the company and served eight years in prison.

4 **Obdurate (Iron Man mask):** They scarcely show their true feelings or human side. They think they need to have this public tough image. Marissa Mayer, Yahoo's CEO, comes across as cold and disconnected to her employees. Her recent policies (maternity leave and long-term telecommuting) have caused outrage. Adopting this persona alienates and pushes people away. By exposing their vulnerability and dropping this mask, leaders inspire their followers to do the same, ending in a more aligned relationship between leaders and followers.

5 **Meek (Mister Fantastic mask):** They appear so humble and act down-to-earth when in fact they are full of conceit. They have this entitlement and superiority complex. However, their true colours are revealed in unguarded moments. I remember once working late and overhearing a manager speaking with a supervisor. He didn't realize I was there and spoke openly to her. As I sat there, I couldn't believe that this was the person I thought I knew. When he came out of his office and saw me by my desk, he seemed disoriented and shocked and asked if I had overheard him. Well, my whole perception of him changed that day.

6 **Proficient (Phantom of the Opera mask):** Some leaders conceal perceived imperfections in favour of a polished image. The demands or expectations that society creates leaves them feeling mediocre and inadequate. They are uncomfortable in their own skin, so they try to measure up and may even employ unethical methods to fit in. Lying on his resume cost former

Bausch & Lomb CEO Ronald Zarrella $1.1 million in bonus after it was revealed he did not have an MBA as recorded. Company officials declined to accept his resignation. He remained in his role for another six years before retiring in 2008. Ironically, he probably didn't need that degree. His prior job experiences were almost certainly enough. Still, like so many people, he seemed to have yearned for a status symbol.

7 **Conformist (Shape-Shifter mask)**: In this case, top management puts pressure on these types of managers to change their principles. Their style may not fit in with the changing culture. There is a shift between their preferred style of behaviour and what the company wants. The difficulty is trying to express your complex but authentic self within a system that wants you to wear a mask for ease of flexibility and productivity. In these types of situations, you could either decide to adapt or leave if it creates inner conflict.

When is wearing a mask okay? If you have low emotional intelligence, wearing a mask may be necessary to cover negative moods such as fear, anger, disappointment, or downheartedness.

"We all wear masks, and the time comes when we cannot remove them without removing some of our own skin." — Andre Berthiaume

When was the last time you looked in the mirror? I don't mean glanced in the mirror. I mean stopped and took a long, hard look. What did you really see? **Are you proud of the image that was reflected**? You might realize your nose had grown (like Pinocchio) or accelerated aging had set in due to continuous wearing of various masks.

In an era of social media where leaders' personal and professional lives are often transparently intertwined, the mask eventually becomes apparent. We may cheat others, but most importantly we are only fooling ourselves. It takes a lot of energy to keep a mask in place. We all have been guilty of masking in some way or the other during our leadership journeys, although the extent to which we layer ourselves varies greatly. Transform yourself by dropping the facade and removing the mask. If you want to be authentic, you need to look at your masks. You might want to hold onto some and let others go. Regardless, **it's an exercise in self-exploration and personal development**. The important thing is to analyze where you have fallen short and then make the necessary changes to take your leadership identity to meaningful heights. Walking in authenticity and genuineness gives freedom.

Part Six

LEADERSHIP PRACTICALITIES

CHAPTER 26

Five Qualities of Truly Remarkable Leaders

We all know the usual traits that are often discussed in leadership. Communication, persistence, commitment, confidence, and integrity are some examples, but let's delve a little deeper and look at **some of the qualities possessed by the truly**

remarkable leaders who pioneered great changes that positively revolutionized our world.

FIVE QUALITIES OF TRULY REMARKABLE LEADERS

1 **Visionaries:** They had extraordinary vision. They saw into the future. Martin Luther King Jr. said, "I have a dream that one day this nation will rise up and live out the true meaning of its creed—we hold these truths to be self-evident: that all men are created equal."

- ⮥ What do you dream of?
- ⮥ Where exactly is your gaze?
- ⮥ How do you see your actions transforming the future?

"The future belongs to those who believe in the beauty of their dreams." —Eleanor Roosevelt

"I dream my painting and I paint my dream." —Vincent van Gogh

2 **Emotional Intelligence:** Their ability to identify and manage their own emotions and the emotions of others was exceptional. Despite being imprisoned unfairly for twenty-seven years, Nelson Mandela never let toxic emotions get the better of him. He kept focused. He realized it wasn't about him but about those he was fighting for. "As I walked out the door toward the gate that would lead to my freedom, I knew if I didn't leave my bitterness and hatred behind, I'd still be in prison," Nelson Mandela said.

3 **Humility and Contentment:** Often, it's in the humility department that modern leaders fail. These remarkable leaders practiced servant leadership. They never saw themselves as better than anyone else or too big to attend to smaller concerns. They acknowledged their weaknesses and failures, preferring to shift the spotlight to others. They were thankful. Material possessions did not entice them. They sought neither fame nor fortune and often endured simple living conditions with great contentment.

4 **Love:** This was their driving force. They sincerely cared about the well-being of others. They were selfless and loved justice. They were passionate about people. They pursued their purpose to improve mankind and work for the greater good of others.

"It is not how much we do, but how much love we put in the doing. It is not how much we give, but how much love we put in the giving." —Mother Teresa

5 **Faith:** They were men and women of faith. They realized what they were attempting was much bigger than themselves and they had to depend on the eternal source. They accepted their mortality and trusted God to take them through. They had inner peace from their beliefs that kept them steadfast.

"My imperfections and failures are as much a blessing from God as my successes and my talents and I lay them both at His feet." —Mahatma Gandhi

We should all strive not to settle for the ordinary but **reach for the extraordinary**. These individuals have set the bar thereby exemplifying what true leadership is really about.

The Most Important Leadership Skill

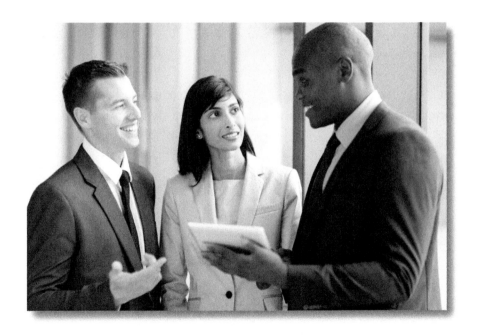

Listening is the most powerful skill a leader can master. Good listening skills in this digital era due to information overload

and shortened attention spans is fast becoming an endangered species.

Science has demonstrated that **hearing impacts how we walk and that even our balance** is influenced by how well we hear. So what we hear is crucial to how we live. The act of listening marks the first step in communication. In Hebrew thought, the seat of wisdom or of intelligence is located not in the brain but in the ears.

THE EAR IS DIVIDED INTO THREE PARTS IDENTICAL WITH 3 LEVELS OF LISTENING:

Level 1—The External Ear: Listening with the head–**Passive Listening**. The listener is concerned with the processing of information. They are **mentally** noting the main points the speaker is making but thinking about their own ideas. They are trying to conceptualize the problem. They focus on their interpretations and are waiting to interject with their solution.

Level 2—The Middle Ear: Listening with the head and body– **Active Listening**. It involves paying attention and making nonverbal cues, appropriate to what is being said. It's listening both **mentally and physically**. The listener shows appreciation

in their body language relaying the message that they are interested in what the speaker has to say. It's reflecting back the main points and summarizing what has been said. They are gathering information to help them form opinions and make decisions. They listen to understand.

Level 3—The Inner Ear: Listening with the heart, head, and body–**Intuitive Listening**. It calls for wisdom. This is crucial to gaining a complete understanding of situations. Without this full understanding, one can easily waste everyone's time by solving the wrong problem or merely addressing a symptom, not the root cause. The skill of intuitive listening is the heartbeat of all communication. Great leaders function at this level. **They listen to beyond what is being said, the hidden meaning.** They read between the lines. They are genuinely attentive to the meaning and significance of what the speaker is saying. They show empathy. This requires **emotional intelligence**. The listener is able pick up on the unspoken clues that hint at a larger story behind the words. Often times after stating your response the speaker may exclaim, "How could you know that?" By practicing the skill of intuitive listening, leaders can make better decisions, build stronger relationships, and resolve problems more quickly.

"The most important thing in communication is hearing what isn't said." —Peter Drucker

Employees want to be heard and they want to be respected. Listening transmits that kind of respect and builds trust. This leads to more motivated and committed team members. Communication is indeed a two way street and involves feedback. It important to ask the right questions, such as "How can I help you?" or "Was the training effective?" Encourage

conversation that provides more in-depth information. *If you genuinely want to listen, people will start talking.* Listening must also be backed up by the appropriate action.

INTUITIVE LISTENING AND SELF-LEADERSHIP

Homing pigeons long have been known to fly hundreds of miles a day and arrive at their destinations with amazing accuracy. In order to navigate, they use infra-sound, low-level background noise in the atmosphere to fly by "images" they hear, practically creating acoustic maps of the environment. Yet *even the best homing pigeons at times have become disoriented*, never returning to their starting points. The worst incident happened in England, when 20,000 birds (valued at more than $600,000) never came back to their lofts.

That's why it is important to *never leave home without your moral compass*. When faced with an ethical dilemma, it serves as a navigator to steer you in the right direction. The temptations to take shortcuts can be overwhelming. Even the smartest of leaders have become disoriented and lost their way, never being able to get back on track. Listening includes listening to that *inner "still small voice."* If something is wrong, don't try to justify it. Even if you get away with it for a time, eventually *the piper must be paid.*

In 2012, businessman Kenneth Hunt, of Hunt Kidd Solicitors, and his business partner Barbara Grayton were both sentenced to face prison terms. Hunt had fiddled £1 million of company accounts to keep it afloat when the recession hit. When Grayton became aware of the fraud, she went along with it. Hunt and Grayton both pleaded guilty to fraud. Defending Hunt,

Attorney Neil Hawes stated, "Both are intelligent individuals, but he made a stupid reckless decision that he will regret for the rest of his life. There was an intention to pay it back."

Famed Russian writer Fyodor Dostoevsky, in the 1800s, spent four years in a Siberian prison for seditious political activities. Later, writing about his ordeal, he discussed some of his fellow prisoners' total lack of remorse for their terrible behaviour. "In the course of several years, I never saw a sign of repentance among these people; not a trace of despondent brooding over their crimes, and the majority of them inwardly considered themselves absolutely in the right." —Joseph Frank, Dostoevsky, the Years of Ordeal (1850-1859).

To achieve balance it is also recommended that you ingest the three pills every leader should take: **Stillness**, **Silence**, and **Solitude**. (Refer to Chapter 22) Your ability to absorb crucial information decreases due to increased pressure, noise, and demands. Distancing oneself from the distractions and taking the time to pause and reflect is essential to clear the mind of clutter.

The brain acts as a computer, analyzing constant signals being sent its way. Based upon the data received from the inner ear, the brain then sends messages to the muscles of the body to maintain balance. *Any disturbance in inner ear results in balance difficulties.*

Organizations can succeed or fail according to the quality of their interactions. Poor communication comes with a high price tag. It accounts for businesses losing millions of dollars each year. That's why *it's important for leaders to master the skill of "**Leading with Listening**."*

CHAPTER 28

Leadership Cycle: Is History Destined to Repeat Itself?

World history is usually taught as the history of civilizations. The significant facts are generally the ones that have had a bearing on the development of those civilizations. Human history is an unending series of repeated cycles. The world is round and almost everything goes through cycles. There are **life cycles, climate cycles, economic cycles, and political cycles**, to name a few. Just look at the circular dial of a watch: the hand revolves around and around, as time recurs in a cycle. It can be argued that *leadership like the rest of our affairs is essentially cyclical in character*. Effective leadership is commonly viewed as central to organizational success.

The leadership cycle includes five stages: Awareness, Development, Maturity, Reinvention, and Decline.

THE LEADERSHIP CYCLE

Stage 1: Leadership Awareness. A leader is born. A situation arises, a leader steps forward, takes the helm, and acts in that capacity. He/she creates the vision and sets goals.

Stage 2: Leadership Development. Based on the organization, type of business, environment and people, the appropriate leadership style is developed. Growth is achieved by observing other leaders as well as from personal experiences.

Stage 3: Leadership Maturity. Leaders at this stage have proven performance. They are confident with their experience and in their abilities and so may become complacent believing what worked in the past will work in the future. They think that past behaviours are indicators of future success. *Many managers get stuck in this stage* and skip Stage 4 (Reinvention), fast forwarding to the Stage 5 (Decline).

"The illiterate of the 21st century will not be those who cannot read and write, but those who cannot learn, unlearn, and relearn." —Alvin Toffler

Stage 4: Leadership Reinvention. This stage is characterized by adaptability and openness to change. Learning is a lifelong process. Successful leaders are always reinventing themselves. They are constantly surveying the environment, thus recognizing the external and internal trends and making the necessary personal changes.

Stage 5: Leadership Decline. Everything comes to an end. A leader must accept when their journey is over and let go. At this stage, once succession planning was embraced the leader's legacy lives on. The goal of true leaders is not to make more followers but more leaders.

Unethical behaviour or poor performance **can thrust a leader to the Stage 5 (Decline),** thereby skipping the sequential order of stages.

THE ECONOMIC CYCLE AND LEADERSHIP STYLES

Does the economic cycle correlate with the different leadership styles? *Just remember nothing happens in isolation.* Everything is interrelated. When the economy is booming do we tend to lean towards more participative leadership styles? And when there is a downturn do we embrace authoritarian styles?

Think back to the days of the Great Depression, when command and obey was the accepted nature of leadership. We see today with the global financial crisis and slowing global economy companies are adopting stringent tactics (downsizing, layoffs, etc.) and some are even reverting to *scientific management and authoritarian leadership* styles.

There a few leaders, like Richard Branson, CEO of the Virgin Group, who really embrace the transformational or charismatic leadership style. On the other hand, Yahoo's CEO Marissa Mayer represents the face of autocratic leadership, which many leaders are adopting to combat the economic downturn.

"If you don't pay attention to the past, you'll never understand the future. It's all linked together." —Sarah Dessen

DOES HISTORY REPEAT ITSELF?
THERE IS A POPULAR SAYING THAT *HISTORY REPEATS ITSELF EVERY FORTY YEARS.*

Let's take a snapshot of the US within three forty-year periods:

1920s—1930s: The Great Depression. The immediate post-war period was one of labour unrest and racial tensions. The depression originated in the United States, after the fall in stock prices that began around September 4, 1929. Unemployment in the US rose to 25 percent. Businesses and factories shut down, and banks failed. It had devastating effects in countries all over the world.

"Don't forget what I discovered, that over ninety percent of all national deficits from 1921 to 1939 were caused by payments for past, present, and future wars." —Franklin D. Roosevelt

1960s—1970s: The US economy entered into the so-called mini-recession of 1966-67. There were high levels of unemployment. Federal budget deficits grew, foreign

competition intensified, and the stock market sagged. Military spending also increased as America's presence in Vietnam grew. Racial tension heightened. Martin Luther King Jr. was assassinated in 1968, which sparked multiple riots.

2000—2015: Military spending increased in the US with its war on Iraq. In 2007 the global financial crisis hit, which resulted in billions in losses. The stock market crashed. Banks failed. Many companies closed their doors. Unemployment hit an all-time high. Racial tensions in the US were on the rise. The global financial crisis led to a slowing global economy and the subsequent European debt crisis.

To a certain degree, some of these factors can be attributed as a cumulative effect of poor leadership on multiple levels.

THE FUTURE

The twenty-first century requires forward-thinking ethical leaders who embrace the bigger picture. They are interested in how their decisions will affect the future. They foresee the road ahead and make the necessary strategic plans. They don't just look ahead but *behind as well* to determine the best plan for progress. They don't get complacent with success.

They are always asking pertinent questions:

- What has worked for us in the past?
- Where did we go wrong?
- How can we improve?
- Why haven't we adopted this strategy?
- Will this strategy be relevant tomorrow?

"You can't connect the dots looking forward, you can only connect them looking back, so you have to trust that the dots will somehow connect in your future … even when it leads you off the well-worn path." —Steve Jobs

SEVERAL TRENDS REPRESENT THE CHANGING CONTEXTS THAT PLAY A CRUCIAL ROLE IN LEADERSHIP DEVELOPMENT:

1 **The Role of technology.** Rapid advances in technology are constantly changing the way we lead.

2 **Multicultural leadership.** There has never been such a mix (melting pot) in the workforce as before. Embracing diversity is a must for every leader.

3 **A Greater concern for followers.** Millennials are expecting and demanding more: reward, recognition, and training and development is essential for job satisfaction. Another major concern is work/life balance. Leaders must understand that a person's work and personal life have reciprocal effects on each other.

4 **Increasing interest in the integrity and character of leaders.** The 1990s witnessed ethical lapses among senior executives and pointed to the fact that greater emphasis on leaders' character and values ought to be required.

5 **Competitive global environment.** The global playing field has levelled. Embracing change management and a culture of learning is a crucial for an organization to be able to compete in the global marketplace.

"Those who do not remember the past are condemned to repeat it." —George Santayana

History clearly shows that it repeats itself. If we would study the past, it has the keys to unlock the mysteries of the future. The beliefs, habits, and practices from our past are powerful tools if used as a springboard into the future. Effective leaders selectively hold onto certain elements of the past, whilst they focus on investing in building for the future.

Are we doomed to repeat the same mistakes? Not necessarily, and that is why it's important to understand the lessons from the past, the realities of the present, and the likely consequences of a decision for the future. We don't just enter the future. We create it.

"The world we have created is a product of our thinking; it cannot be changed without changing our thinking."—Albert Einstein

CHAPTER 29

The Five Dimensions of Leadership

Leadership has been referred to as an **art**. Art by definition is the expression or application of human creative skill and imagination, typically in a visual form such as painting or

sculpture, producing works to be appreciated primarily for their beauty or emotional power.

Leadership is indeed an **artistic expression** and as such should not be one dimensional. One dimensional leaders cannot provide the kind of leadership that leads to innovation, social change, and business transformation. *True leaders display artistic mastery and are able to re-create, restore, and reconstruct an organization from its ruins*. Their touch can bring an ailing organization back to life. This is indeed the test of true leadership; taking nothing and making it into something. Leadership is about creating. Their accomplishments leave us in a sense of awe as we gaze upon the profound grandeur of aesthetic design. This creative artistic expression is rooted in their being.

"Anyone can hold the helm when the sea is calm." —Publilius Syrus

THE FIVE DIMENSIONS OF MULTIFACETED LEADERSHIP INCLUDE THE LEADER AS AN ARTIST, ARCHITECT, POTTER, SCULPTOR, AND MUSIC CONDUCTOR.

Numerous companies have been on the brink of disaster only to be brought back to life under new leadership.

1 **A Leader as an Artist:** Great leaders are able to *paint a vision* that projects optimism and inspires others to work toward creating it. *"How earnestly and perseveringly the artist labours to transfer to canvas a perfect likeness of his model."* It's so clear, real, and tangible that they infuse passion and

energy into their work and those they lead. They are creative innovators and visionaries. They paint a picture of the future that is captivating and compelling, and coupled with their talent and dedication, they convince and mobilize others to get on board. Knowing what needs to be done is one thing, but communicating that and inspiring others to jump on that boat is another thing.

STEVE JOBS (APPLE CEO FROM 1996-2011)

Steve Jobs, Apple's co-founder, left the company in 1985 after a bitter power struggle. Apple rehired him to lead their recovery in 1996 when the company was struggling and stock prices had tumbled. He became CEO in 1997. His focus was on **creating the next big thing**. As the new CEO of the company, Jobs oversaw the development of iMac, the iPod, iTunes, and the iPhone. He also restored Apple's image as a technological leader. Under Jobs's lead, Apple stock rose more than 9,000 percent. This led to Apple becoming the world's most valuable publicly traded company in 2011. In poor health, Jobs resigned in August 2011, and he died two months later from pancreatic cancer. The re-invigoration of the company is regarded by many commentators as one of the greatest turnarounds in business history. Steve Jobs has been referred to as a *futurist* and has been described as a "Father of the Digital Revolution" and "*the master evangelist of the digital age.*"

2 **A Leader as an Architect:** He/she designs blueprints of the future through *planning*, *organizing*, and *goal setting* to give clear direction. A leader instinctively conveys the best course of action for their followers to pursue. They focus on creating and maintaining the conditions for effectively executing plans. Each person understands how their work contributes. History provides us examples of those who appeared to know instinctively the best course to follow. George Washington, for example, as Ellis (2005) wrote: "his judgement on all the major political and military questions had invariably proved prescient... his genius was his judgement."

ED WHITACRE (GM CEO FROM 2009-2010)

On June 9, 2009, General Motors named Ed Whitacre as chairman. He took the position when the automaker emerged from bankruptcy proceedings and were facing a government

bailout. He restructured the company's holdings and cancelled projects that seemed unprofitable. He earned the nickname of "GM's Reaper," noted for his strong desire to "kill off" brands and projects, such as Saab and a sub-volt Toyota Prius competitor planned for Chevrolet. Under his leadership, GM launched the biggest IPO in history at $23.1 billion. Whitacre had stated he would leave after "returning GM to greatness." He stepped down from his post in September 2010.

3 **A Leader as a Potter:** A fundamental purpose inherent to most *artistic* disciplines is the underlying intention to appeal to, and connect with, human emotion. A leader as a potter is focused on relationship building and team building. He/she is guided by values and principles and gets personal in molding, shaping, and refining their followers. They build teams rather than groups. Their focus is on the people that create the results. Attributes of such a leader include empathy, patience, humility, authenticity, and integrity. Reward and recognition are central to them. Coaching and mentoring are crucial.

Effective leaders are able to build relationships at all levels from staff, customers, vendors, and stakeholders.

DOUG CONANT (CAMPBELL'S SOUP CEO FROM 2001- 2011)

Doug Conant took over the role of CEO at Campbell's Soup in 2001. Sales were falling due to poor management decisions to raise prices and the company had lost half its market value. Conant believed the key to a successful company was employee engagement. The strategy isn't complicated. "To win in the marketplace," he said, "**we believe you must first win in the workplace**. I'm obsessed with keeping employee engagement front and centre and keeping up energy around it... One of the first things I did was make it clear I understood that Campbell's as an organization needed to demonstrate its commitment to its people before they could be expected to demonstrate their own extraordinary commitment to it and its success." Under Conant's leadership, Campbell's stock outperformed the Standard & Poor's Index. He retired in 2011 after completing his ten-year plan.

4 **A Leader as a Sculptor:** This is where a leader must eliminate entrenched policies, procedures, and practices that thwart efforts to realize the vision. They may be bureaucratic, technological, procedural, or simple artifacts inclusive of old ways of thinking. A leader needs to weigh the RIO (return on investment) on removing obstacles. It's important to clarify priorities, provide adequate resources, and welcome feedback. *"How diligently the sculptor hews and chisels out the stone into a counterpart of the image he is envisioning."* This may however meet with much resistance from those who

are accustomed to the old way of doing things. This may also mean letting go of individuals who are not in alignment with the goals of the organization.

GORDON BETHUNE (CONTINENTAL AIRLINES CEO FROM 1994-2004)

When Gordon Bethune took over in 1994 as COO and president of Continental Airlines the troubled airline had twice faced bankruptcy and was again headed that direction. The company's performance ranked last for industry metrics. Bethune quickly made his mark on the carrier, recognizing that a good airline was defined by customer satisfaction. Continental went from being ranked last in every measurable performance category to winning more J.D. Power and Associates awards for customer satisfaction than any other airline in the world. Under his leadership Continental's stock price rose from $2 to over $50 per share. In just twelve months, the company went from a net loss of $613 million to a net profit of $224 million. Bethune retired from his post in 2004.

5 **A Leader as a Music Conductor:** People are hired to produce deliverables or outputs in the belief that the effort will lead to an outcome, such as more revenue, higher profits, strategic alliances, greater market penetration, and higher retention of customers. *Leaders act as guides* to the organizations they lead. They choose the works to be performed and study their scores to which they may make certain adjustments. They bring all the elements together for the performance of a lifetime. It all boils down to performance in the end. Great leaders get results.

FOUR KEY PERFORMANCE INDICATORS:

- ➲ Profit. This is a very important for any type of business.

- ➲ Stakeholder and Customer Satisfaction. Without customers companies wouldn't exist.

- ➲ Internal Process Quality. Processes must be efficient and effective.

- ➲ Employee Satisfaction. The people in any organization are the ultimate drivers of success or failure.

RICHARD TEERLINK (HARLEY-DAVIDSON CEO FROM 1989-1997)

Richard Teerlink joined Harley-Davidson in 1981 as CFO. At this time the company had US market share of 15 percent and had reported a loss of $15 million. Teerlink became CEO in 1989 and focused mainly on increasing quality and improving service to customers and dealers. By the end of his tenure, Harley-Davidson recovered its US market share to 50 percent and posted annual sales of more than $1.7 billion. Teerlink left his post as CEO in 1997, and served on Harley-Davidson's board of directors until 2002.

Conquering the five dimensions of leadership is a balancing act only the most accomplished leaders master. Are you performing within this spectrum?

CHAPTER 30

How to Be an Effective Change Leader

Leadership is directly correlated to and is synonymous with change. Leadership in the 21st century requires the

ability to continuously manage crisis and change. Change is often a complex and arduous process. **Change calls for a transformation in the way people think, systems and processes, organizational behaviour and subsequent culture.** Good leaders embrace the concept of change management. Change management is a structured approach to transitioning individuals, teams and organizations from a current state to a desired future state. It's about enlisting people and keeping them committed. *Change is the new normal for leadership success.* To remain stagnant is to become extinct: *A thing of the past.*

The mistake that most organizations make is they gave the systems and process their primary attention whilst people were just secondary. **Change should be people-centred.** In certain situations where things are unfavourable and a downsizing strategy may be utilized, as the leader you have the power to make the whole process more humane and not just callous. Those employees who are left will always be suspicious of management. *Certain changes may be non-negotiable, but how you lead it makes all the difference.*

Resistance to change is the largest obstacle that leaders are faced with when initiating a change effort. A 2006 study by *Harvard Business Review* found that 66 percent of change initiatives fail to achieve their desired business outcomes.

The Five Most Common Obstacles to Change:

Employee resistance

- ⋑ Communication breakdown
- ⋑ Insufficient time devoted to training

- ⊃ Staff turnover during transition
- ⊃ Cost exceeded budget

CHANGE MANAGEMENT MUST BE APPROACHED AT THE FOLLOWING THREE LEVELS:

1 Self

- ⊃ **What is my role as a change leader?** Vision, Communication, and Emotional Intelligence
- ⊃ **What is my leadership style in driving significant change?** Transformational Leadership

It's important for leaders to understand the complexity of implementing a change initiative and their role and responsibilities in leading and supporting that change.

Create the vision: A change effort must start with a vision that *paints a compelling picture of the desired future.* It will assist in motivating those that are impacted to take action in the right direction. It's important to clarify the rationale behind the change and connect the big picture to the purpose. You must also be passionate. *Show enthusiasm and commitment.*

Communication *is crucial:* How you communicate the change vision can either ease or escalate fear. *Communication should be simple and heartfelt* thereby speaking to anxieties, confusion, anger, and distrust. Supply realistic details of both the positives and negatives of the change and provide key information on a consistent basis. Be a person of your word. Don't make promises you cannot keep. Plan to assess

employee's reactions to change via surveys. Maintain regular review meetings with key staff and adapt the organization's meeting structure and agendas to support the improved status and processes.

As a leader, force yourself to be at the front lines. This will definitely boost morale. Silence will be interpreted unfavourably, and gaps will be filled by the grapevine.

"Progress is impossible without change, and those who cannot change their minds cannot change anything." —George Bernard Shaw

Emotional intelligence. It's important to consider the personal impact on those affected, and their journey towards working and behaving in new ways to support the change. *Emotionally intelligent leaders are able to help others manage difficult change.* Managing the way you respond to events and your ability to communicate effectively is essential for leaders of organizational change.

Being emotionally intelligent includes the following skills which are recognized as central to success in leadership and to your ability to manage change.

- **Self-Awareness**: The ability to understand your responses to situations and other people's feelings and emotion.
- **Self-Management**: The ability to the ability to harness emotions to facilitate cognitive activities as problem solving and to motivate ourselves.
- **Social Awareness**: The ability to recognize and understand the feelings and emotions of others. This includes skills in empathy.

⮞ **Relationship Management**: The ability to express your emotions and to communicate effectively.

I once worked for an organization that undertook a major change that included a relocation and an upgrade in system. Even the name of the department was changed and our manager Joseph was reassigned so quickly we never even got to give him a farewell celebration. The change process was very difficult for employees to deal with, as the new management lacked emotional intelligence. We never got closure. Even the mentioning of Joseph's name became taboo.

That's why it's important to assess and address how the changes will affect people. **Let employees know that you understand** the range of emotions associated with change. Losses should be openly acknowledged. Show care and concern and allow them time to grieve. Treat the past with respect. *Allow people to take a piece of the past with them* as this will allow a smoother acceptance to change.

TRANSFORMATION LEADERSHIP STYLE

Included within this class of theories are Burns and Bass's transformational theory. Transformational leadership is a style of leadership where the leader is charged with identifying the needed change, creating a vision to guide the change through inspiration, and executing the change in tandem with committed members of the group. *It focuses on developing mutual trust, fostering the leadership abilities of others, and setting goals that cause followers to optimize their performance.*

The concept of transformational leadership theory was initially introduced by James MacGregor Burns in 1978. According to

Burns, the transforming approach creates significant change in the life of people and organizations. *Through the strength of their vision and personality, transformational leaders are able to inspire followers to change expectations, perceptions, and motivations to work towards common goals.*

Bernard M. Bass expanded upon Burns's original ideas in 1985. His theory identifies four aspects of effective leadership, which include inspirational motivation, idealized influence, intellectual stimulation, and individualized consideration. A leader who exhibits these qualities will inspire subordinates to put the long-term interest of the organization ahead of their own short-term interest.

2 People

> ⮑ **How do I understand and respond to different perspectives?** The Change Curve and the Three Types of Individual attitudes towards change

> ⮑ **How do I help my team through change?** Training and Coaching, Reward and Recognition

Most employees resist change due to job insecurity, mistrust of management, increased workload, and fewer opportunities for advancement. Leaders must show commitment to the change initiative but above all to the people who are affected by the change. This requires relationship building, thus leaders must display authenticity, integrity, empathy, and humility in their approach. Change and influence are inextricably linked. Influence is about gaining not only compliance but also the commitment necessary to successfully drive change.

Having an understanding of your team's personality dimensions will provide you with additional insight on how best to guide the transition.

THE THREE TYPES OF INDIVIDUAL ATTITUDES TOWARDS CHANGE

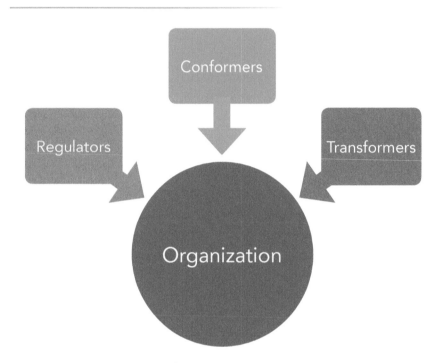

Regulators: They *fail to see any positive outcomes* and keep challenging the process of change. They value habits and complacency. They do not want to step out of their comfort zone so look for every opportunity to blame and criticize. They secretly harbour fear of the unknown. They have a hard time in coming to terms with the change as they always revert to and compare the present with the past. These individuals would require more training and focus groups to discuss their concerns.

Conformers: They are interested but not totally convinced, therefore would need persuasion. They want to see what's in it for them. They rely on information and can swing on either side. Hence, more emphasis needs to be placed on these

marginal constituents to get them actively involved in the change process. Eventually when the change is implemented they go along with it, *"just because it's policy."*

Transformers, otherwise known as the experimenters—the free spirited. They openly welcome and champion the change, always eagerly providing suggestions and feedback. They quickly embrace the principle of "out with the old, in with the new" and easily adapt to the new environment.

The goal is to develop a powerful change agents network. It's important to get the right people in place who are fully committed to the change initiative and have the power influence to drive the change effort at all levels.

"Acceptance makes an incredible fertile soil for the seeds of change." —Steve Maraboli

The Change Curve Model by Elisabeth Kubler-Ross (1969) describes the four stages most people go through as they adjust to change. It is a popular model which is widely used in business and change management to understand the stages of personal transition and organizational change. With knowledge of the Change Curve, you can plan how you'll minimize the negative impact of the change and help people adapt more quickly to it.

Stage 1: Status Quo. When a change is first introduced, people's initial reaction may be shock or denial. They react to the challenge to the status quo.

Stage 2: Disruption. They may display fear or anger, and actively resist the changes. The organization experiences

disruption which, if not carefully managed, can quickly spiral into chaos.

Stage 3: Exploration. They begin testing and exploring what the changes mean and eventually resistance gives way to acceptance.

Stage 4: Rebuilding. They embrace the change. They are committed to building the new ways of working. Only when people get to this stage can the organization really start to reap the benefits of change.

Training and Coaching. Assess training needs driven by the change. By comparing existing skills and competencies with the skills you want people to have, you can make an informed decision about the type of training each person or team needs and provide the necessary training and remove obstacles to empower people. Train, coach, and mentor personnel where necessary and invite continued involvement in the processes. Listen to the concerns of those close to the front lines as their insights and experience are critical to execution and success. Training should be properly structured and not rushed. This should build confidence around the change effort. Encourage your employees to think of new ways of doing things.

Reward and Recognition. This concept should be present in every leader's DNA. *It should be something they are passionate and sincere about.* If leaders are to promote and sustain positive behavioural change a simultaneous change in the performance management process must be accompanied. If you want to get results you need to have the behaviours to get results, and rewards and incentives are reinforcers of behaviours. Without positive reinforcement in the midst of change, engagement and employee morale are at risk. For

organizational success, it's critical for employees to execute on strategic objectives promptly. You want to retain top talent and you also want your employees to stay engaged during the transition period so that productivity does not take a plunge. It's important to tailor rewards or motivational tools to ensure they resonate with the target audience. Younger generations like the Millennials can have vastly different reward systems than Gen-Xers or Baby Boomers. Recognition is also one of the most important rewards employees can receive. Focus on creating a culture of recognition. Leaders should always be on the look out to spot good behaviours and be quick to openly praise the recipient of these.

3 Organization

- ➲ **How do I lead change in context of the larger organizational culture?** Impact Analysis and Five Step Process for smooth transition
- ➲ **What should be done to ensure change is sustainable?** Adoption of Change Framework – Lewin's Change Model

Poor planning and inconsistent execution of change initiatives can stop a company in its tracks.

Impact Analysis. It's important to brainstorm the major areas affected by the decision change, and then formulate:

- ➲ The actions you'll need to take to manage or mitigate these consequences.
- ➲ The contingency strategy needed to manage the situation should the negative consequences arise.

Remember that few changes happen in isolation.

257

FIVE STEP PROCESS FOR A SMOOTH TRANSITION

1 **Access Organizational Goals:** Once the project has been identified, turn your attention to developing goals in line with the desired future state. Goals should be SMART: specific, measurable, agreed upon, realistic, and time-based.

2 **Gap Analysis:** This is an important tool for determining what you need to do to meet the change objectives. Determine what steps need to be taken in order to move from the current state to the desired future state. If your organization does not have the structure in place to support the people you will be driving, the organization trying to deliver results requires lots of extra effort and it will be a very slow process.

3 **Create the Plan:** A step by step plan should be created. By working through the steps with your team, you're building *joint ownership* and commitment that will help you to drive the change. Let them be a part of that process so that they also feel some ownership over the change and the path to get there. Allow for flexibility; the plan should not be clad in iron. Listen to everyone carefully and welcome feedback.

4 **Implement the Plan:** This process can be lengthy and almost certainly will not happen in a matter of just a few days. It will take time for people to feel comfortable and start to act in ways that are supporting the change initiative. There may be some confusion at this point, though with a properly structured approach to the change this can be managed well. Create short term wins and celebrate successes.

5 **Monitoring and Evaluation:** This is where you verify the degree of adoption of the changed environment. Are

employees doing what they're supposed to be doing, or are they clinging to the old ways? How are we monitoring and measuring their progress? Feedback is important at this stage. It's also essential that the performance management system should also be reviewed to confirm if it's effective. The change process must be intertwined with the performance management system to ensure sustainability.

Understanding which stage of growth the organization is at will drive the change strategy.

Organizations normally go through four main changes throughout their growth. Based on a basic stages model, Steven Klepper (1997) describes these stages as:

Formative Period. This is when a new organization is just getting started. Although there is a *founding vision* there are no formal definitions.

Rapid Growth Period. Direction and coordination are added to the organization to sustain growth and solidify gains.

Mature Period. The strong growth curve levels off to the overall pace of the economy.

Declining Period. For many organizations it means downsizing and reorganization. The goal is to get out of the old and into something new. Success in this period means that the four periods start over again.

Failure to follow through with the needed changes in any of the four growth periods means the decline of an organization.

The Kurt Lewin Change Theory Model (1947) is very much a significant part of change management strategies for managing

change in the twenty-first century. It is based around a three-step process (*Unfreeze-Change-Freeze*) that provides a high-level approach to change. *It gives a framework to implement a change effort.* Kurt Lewin's model requires a process be in place that supports and maintains the changes. Lewin's Three-Step Change Model phases are:

Unfreeze: The first step in the process of changing behaviour is to unfreeze the existing situation. It involves reducing the restraining forces that are striving to maintain the status quo, and dismantling the current mind-set.

Transition: The second step in the process of changing behaviour is movement. There may be a period of some confusion as the move from the old to the new way of doing things occurs. It will involve a transition period. In order to gain efficiency, people will have to take on new tasks and responsibilities, which entails a learning curve.

Freeze: The final stage is crystallizing the adaptation of new standard as norm. Change will only reach its full effect if it's made permanent so every effort must be made to cement it. The organization may revert to its former ways of doing things at this point unless the changes are reinforced through freezing.

This model works whether the changes are strategic, reactive, or pre-emptive.

"If we don't change, we don't grow. If we don't grow, we aren't really living." —Anatole France

Change management doesn't necessarily mean stability is out the door. For change to be effective stability and change must be held in proper balance to achieve total benefits.

Stability ensures the current business model is effective and efficient, whilst **change** is focused on implementing the changes necessary to be more effective in the future. *The two must co-exist.* The stability to change ratio depends on the people, organization, and environment in which a business operates.

Today's business world is highly competitive and the global marketplace is constantly evolving. **The winners and losers of this global competition are determined by one factor: change.** Companies must learn how to embrace change and treat change management as a critical discipline. Change management is about people. More emphasis should be given to the people who are responsible for adopting the new system to ensure the change initiative is successfully implemented. The easier you can make this journey for people, the sooner your organization will benefit, and the more likely you are to be successful.

CHAPTER 31

Unlocking The Mystery of Leadership

Life is full of mysteries, physicist David Deutsch wrote that **"every day events are stupendously complex when expressed in terms of fundamental physics."** Despite all the

research that has taken place about the nature of leadership, experts and scholars have long acknowledged that many aspects of leadership remain a mystery.

Leadership is a fascinating theme but to unlock the mysteries surrounding leadership requires us to step back into history. Often leaders have been identified as possessing some remarkable quality that sets them apart from others. Not only is there a question of understanding these traits and being able to define them; but more importantly, can they be learned, acquired or measured? Sadly though, soft skills cannot be fully measured. The proportion of components required for each leadership role is largely situational and may be dependent on innate qualities. What works for one person may not necessarily work for someone else.

The American philosopher Sidney Hook distinguished between the "eventful" man who happened to be involved in an historic situation but without really determining its course, and the "event-making" man whose actions influenced subsequent developments along a quite different course. Hook's distinction, recognized the general belief that a hero is great not only because of what he does but because of who he is—because of his traits.

As children we were brought up on mythological tales of kings, princesses, warriors and villains. Additionally, movies featuring superheroes are amongst the highest gross earnings at the box office.

The development of leadership is linked to the development of human society. When we look at leadership history during the many centuries mankind has lived in a community or organized context. **The medieval times was a marvellous**

period that showcased a new era in leadership. Medieval life encompasses one of the most exciting, captivating and turbulent times in English and European History. It also included the Viking age. The medieval people of the middle ages and dark ages were fearless as they sought to conquer new lands. Leadership blossomed and was characterized by crystal clear vision, victories and defeats and rapid change.

The middle ages has been regarded as extending approximately from the end of the fifth century AD, when the control of the Roman Empire had ended, until the end of the fifteenth century AD, when the modern world was considered to have begun. It was considered as the beginning of a new age.

THE MIDDLE AGES IS CONSIDERED TO HAVE CONSISTED OF:

1. The Early Middle Ages (Dark Ages): 5th – 10th century

2. The High Middle Ages: 11th – 13th century

3. The Late Middle Ages: 14th – 15th century

The events in medieval history continued down the timeline until 1485 which ended the War of the Roses, and saw the start of the Tudor dynasty and the emergence of the Renaissance.

FAMOUS MEDIEVAL PEOPLE–LEGENDS AND MYTHS

Some famous medieval people includes El Cid, William Tell, William Wallace (Braveheart), Marco Polo, Johann Gutenberg,

Frederick Barbarossa, Peter the Hermit, Richard the Lionheart, Bertrand du Guesclin, Alexander Nevsky, Robin Hood, King Arthur and Knights of the Round Table.

We can definitely learn a few lessons from King Arthur who embraced the "**The Round Table Leadership**" style which is very applicable today. Round table leadership is inspiring and engaging.

FIVE LEADERSHIP STYLES EVIDENT IN ROUND TABLE LEADERSHIP

Autocratic Leadership: Command and control. Sometimes leadership means you just have to take the helm and show why you are the appointed leader. A leader must display his decision making abilities and must stand his ground even in unpopular circumstances. He/she must command respect. Collaboration is good but certain situations calls for taking complete control.

Transformational Leadership: Speaks to inspiring people with the compass direction of a powerful vision. It involves projecting a vision that help people develop commitment and showing a path forward to fulfil this vision.

In the Fifth Discipline, Peter Senge emphasizes that many leaders have vision, but not so many effectively cultivate a shared vision. It is the shared vision that mobilizes people's minds and hearts

Participative Leadership: Facilitates the groups' collective knowledge. Collaborative conversations embrace diverse skills and engaging in joint problem creates better insights.

In a Harvard Business Review article, Ronald Heifetz and Donald Laurie explored how Colin Marshall, CEO of British Airways in the 1980's, led a reform initiative that emphasized inquiry processes. Marshall saw a declining enterprise. Underneath the operational problems, he suspected there were cultural problems. Rather that decree a solution, Marshall initiated an inquiry process involving the company's leadership. This involved feedback from management, staff and customers. Conflicts were seen as clues to the underlying cultural problems. Through this inquiry process, Marshall led the leadership of British Airways to the conclusion that the problems could not be adequately addressed by tweaking the system but cultural matters that required a large scale cultural shift toward responsible collaboration.

Charismatic Leadership: The personal charisma of the leader induces astounding and sometimes blinding degrees of commitment. It causes people to be attracted to them. It enables them to achieve remarkable outcomes. "Charisma," coming from the Greek word meaning "gift." It was thought that this quality was a gift that was bestowed upon some and not others.

Transactional Leadership: Bernard Bass introduced an insightful contrast between transactional leadership and transformational leadership. In transactional leadership, the transaction is the Deal—effort and fealty are traded for the benefits and if the deal as it stands does not generate the needed direction and motivation, the transactional leader can provide clearer direction within the present deal or work out a new deal with revised directions and stronger incentives.

MEDIEVAL PEOPLE TITLES, POSITIONS AND CLASSES

Life in the Medieval Castle was governed by the pyramid-shaped Feudal System. This was based on the belief that the land belonged to God, but that the Kings, who ruled by Divine Right, managed the land and used it as they wished.

The **Pyramid-shaped Feudal System** had seven classes. There was built in protocols. The layers of structure are amazing and complex.

Royalty — King, Queen, Princes, Princess, Regent, Queen mother, etc.

Clergy — Pope, Deacon, Monk, Priest, Cleric, Vicar, Scribe, etc.

Nobility — Viceroy and Vicereine, Archduke and Archduchess, Marquess and Marchioness, Count and Countess, Baronet and Baronetess, Knight and Dame (Lord and Lady), etc.

Tradesmen & Merchants — Moneyer, Apprentice, Master Craftsman, Artillator, Merchant, Peddler, etc.

Castle Workers — Court officials, Chamberlain, Chancellor, Butler, Grandmaster, Herald, Steward, Lady-in-Waiting, Page, etc.

Entertainers — Minstrel, Jongleur, Gleeman, Mummers, Bard, Thespians, etc.

Military — Musketeers, Falconets, Foot soldier, Lancers, Constable, Sergeant, etc.

Peasantry — Villein, Cottager, Commoner, Peasant, Labourer, Maid, Cook, Servant, etc.

Leaders at the top of the pyramid can sometimes have an identity problem. They often think for whatever reason, their word is law and that respect is given by their position. However, true leaders get people to follow because they want to follow. They don't have to remind people that they are the leader.

The worst leaders act as lords in a feudal sense. Their style is incredibly autocratic. They exclusively own the mission and use people to fulfil their purposes without consultation and grace.

Does your structure and culture leads more to lordship or leadership?

LORDSHIP LEADS TO RESENTMENT, DISTRUST AND REBELLION.

Leadership goes beyond hierarchical designations. Great leaders learn to not only lead by command but use influence and grace to get people on board with the mission. They communicate directly and effectively. An often overlooked facet is leadership spirit. How you lead attitudinally is far more important than how you lead mechanically.

FROM LORDSHIP TO LEADERSHIP—TEN SKILLS REQUIRED FOR EFFECTIVE ROUND TABLE LEADERSHIP:

1 **Foreteller:** A leader must see farther than others see. There must be a clear vision underlying the proposed direction. A leader is responsible for the creation of sense of purpose in the organization. Organization structure influences receptivity to vision centred leadership.

Pawar and Eastman adopted an insightful five way analysis of structure developed by Henry Mintzberg of McGill University. They argued that vision-centred leadership suits simple structures and small enterprises because it's both easy to reach people and acceptable to push a vision. However, it finds less ready acceptance in highly bureaucratic large organizations. Pawar and Eastman concluded that the leader must somehow surmount the structural barriers in order to move the vision forward.

2 **Enchanter:** Leadership is about influencing. It requires good communication skills, to inspire others to keep going even when the journey gets tough. The CEO needs to inspire his company with the full knowledge that the competition ranges from tiny start-ups to large corporations. King Arthur couldn't win through brute force: his troops were outnumbered. He needed to employ superior battle strategies and tactics. Arthur motivated his knights to embark on an impossible quest to find the Holy Grail.

3 **Friar:** Integrity and Authenticity are essential traits of good leaders. Good leaders lead by example. They radiate moral authority which is transferred down to the followers. Values are the beacons for finding the right direction and making ethical decisions. In spite of how talented or charismatic a leader may be, if he lacks these skills his term in office will be cut short.

4 **Gatekeeper:** The leader controls access to who enters and leaves the team. He chooses a highly skilled workforce in order to accomplish the goals of the organization. Individuals selected should be in alignment with the vision of the organization and be able to work together as a team. King Arthur needed to recruit the top knights to sit at the Round Table. To achieve good judgment, it is of particular importance that a leader is surrounded by sincere reliable subjects who are able to transfer observable realities and insights.

5 **Scribbler: A scribe.** Leaders are relied upon for their knowledge and skills which determines the quality off the performance of the organization. To perform effectively leaders need to always "take notes" to keep abreast with what's going on around them to be able to make informed decisions. Education in leadership needs to begin with observation.

They learn from the world's best leaders/teachers. They focus on personal development as they know there is always room for growth. Therefore leaders see continuous learning as a compulsory investment if they are to be successful and so make the necessary commitments to keep well learnt.

6 **Arbiter:** There would always be internal disruptions within the camp due to conflicting personalities as not everyone will see eye to eye. Good leaders show impartiality. They are fair. They tackle internal issues before they become emergencies. They apply wisdom in their approach and draw conclusions based on Emotional Intelligence. King Arthur's court was not without its share of interpersonal problems and politics, Lancelot's affair with Guinevere and Mordred's betrayal being the most famous. **Arthur himself handled these situations poorly** by not confronting the various parties early and dealing with the situation when it was small and could be easily managed.

7 **Challenger and Defender:** Leaders are both challengers and defenders. They are quick to stand up for their team and put their best interest first. Moreover, leaders are always challenging their followers with more responsibility to make them grow. They work with them to reach their full potential. King Arthur trained the next generation of leaders through holding tournaments. The tournaments of the King Arthur stories were the pseudo battlegrounds in which knights honed their skills and kept themselves ready for war.

Business scholar James Collins and a research team conducted a five year historical analysis of companies that over time had made a sustained transition from good to great. Succession planning was a problem. Collins writes, "In over three quarters

of the comparison companies, we found executives who set their successors up for failure or chose weak successors, or both."

8 **Squire:** Leadership starts and ends servant leadership. Leaders lift up others—never themselves. True Leaders don't trample, scratch, and claw their way to get to the top. They don't think certain tasks are beneath their dignity to perform. They are humble and keep their eyes open for ways to serve, even in very small ways. They see the need and meet it, rather than waiting for someone else to do it. They gain the trust and respect of their team by their sincerity and humility displayed.

9 **Crusader:** A leader should be quick to openly reward and recognize his team for their efforts and achievements. It's important to celebrate at each interval, not only huge victories but small successes. Motivation is a key factor of performance and leaders should be aware of the source of motivation for their team. King Arthur needed the good will and support of the nobles and knights so he granted them payment of money, titles, and/or fief (land) in return for their military services.

10 **Almoner:** The nature of the work of the almoner is often confidential so much of what he does will be unknown to the followers. The role itself requires tact, diplomacy and discretion; they contribute to the development of people. True leaders are an asset to their society. They support social, charitable and environmental affairs. They seek the advancement not only of themselves and their team but in the society in which they operate in. They recognize the importance of giving and the need to help others as the way forward.

Although the modern CEO is somewhat less likely to be on horseback charging in front of the battle or conquering new

kingdoms. When you strip away the scenery and time zone, the fundamental problems and solutions aren't much different. There is no general leadership model one can apply that leads to success. Decoding the mystery of leadership calls for time travel into history. The middle ages hold valuable insights to unravel the mysteries surrounding leadership. Although it's impossible to quantify leadership traits nonetheless we can determine the core competencies required and focus on developing these which increases the probability of leadership success.

CHAPTER 32

Leadership and Corporate Social Responsibility

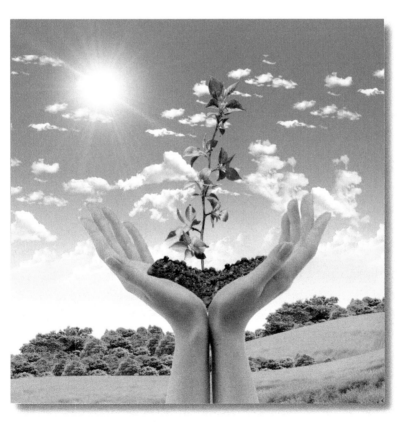

The story is told of John, a young man, standing at the end of a bridge. He was waiting for the bus to take him to his home, nearly an hour's distance away. It was a warm summer day, and many children were swimming in the millpond below the bridge. As John watched them, he noticed one of the smaller boys began to drift farther and farther from the shore. Suddenly, the little boy threw up his hands and disappeared under the water. John's first impulse was to run down the bridge and try to help the little boy that was drowning. But as he looked up, his bus was fast approaching. He casually brushed it off and decided with so many good swimmers in the millpond, surely someone else would help him. So he boarded the bus and went home. Upon arriving home, he found his mother lying unconscious on the floor. He hastened to bathe her face and rub her hands. As she regained consciousness, she cried out, "Oh John, your brother Willie has just drowned in the millpond." Then from John lip's came the agonizing cry, "If I had only known it was my brother William."

As we help others, many times we are indirectly helping ourselves and our own families.

All of which leads to the question: how should leaders relate to corporate social responsibility?

In today's changing world, the concept of corporate social responsibility is high on the agenda. The term corporate social responsibility became popular in the 1960s. Corporate *Social responsibility* (CSR) is an ethical framework which suggests that an entity, be it an organization or individual, has an obligation to act for the benefit of society at large. *Social responsibility* is a duty every leader should perform. CSR is becoming more mainstream as forward-thinking companies

embed sustainability into the core of their business operations to create shared value for business and society. Technology has brought global connectivity and enabled awareness for social issues that were once vague or unknown.

Susan Cooney, founder of crowdfunding philanthropy platform Givelocity, said that a company's CSR strategy is a big factor in where today's top talent chooses to work.

"The next generation of employees is seeking out employers that are focused on the triple bottom line: people, planet and revenue," Cooney told Business News Daily. "Coming out of the recession, corporate revenue has been getting stronger. Companies are encouraged to put that increased profit into programs that give back."

"Leadership requires the courage to make decisions that will benefit the next generation." —Alan Autry

TYPES OF CORPORATE SOCIAL RESPONSIBILITY

Many leaders are aware of their **legal and economic responsibilities** (earn a return for their stakeholders within the confines of the law) but may shirk on the following because it may not seem as important.

HERE ARE 3 CATEGORIES OF SOCIAL RESPONSIBILITY THAT LEADERS CAN SHOULD PLACE MORE EMPHASIS ON:

Environment: Years ago an environmentalist entered a seafood restaurant. He went to a large tank, where half a

dozen lobsters lay. Moving stealthily, he reached into the tank, grabbed the first lobster he could, threw it into the bag, and ran. He then put the lobster in a tank in his car and drove to the shore. There, a helicopter took him over the ocean, and he then returned the lobster to the sea. A lobster liberator strikes again! Caring about the environment is one thing, but stealing a lobster out of a restaurant and taking it, by helicopter, back to the ocean does seem a bit extreme. Putting aside the eccentricity of the lobster liberators, how can we take better care of our environment?

Sadly exploitation and corruption exist within the domain of management responsibility. Many leaders have been involved in the degradation of the earth's resources. Human survival depends on the health of the ecosystem. An ecosystem is comprised of communities of plants, animals and other organisms in a particular area that interact with each other and their surrounding environment. Virtually all of earth's ecosystems have been significantly transformed through human actions. Changes have been especially rapid in the last 50 years due to the vast destruction of the forests and the increasing emission of destructive gases resulting in the depletion of the *protective ozone layer*. These problems are largely due to the egoistical pursuit of "wants" which is facilitated through unrestrained consumption, mounting production, and diminution of non-renewable resources. The environmental crisis is entrenched in greed and refusal to practice good stewardship.

Environmental responsibility involves efforts to protect air, water, and land from any harmful effects. With a worldwide call to "**Go Green**" sustainable business practices consider not only the use of resources in production, but also the assurance

that those resources can be replenished for future use. A business can start with simple activities. Recycling is easy and very achievable for the average workplace. According to the Inc. magazine, 80 to 90 percent of materials used in today's workplace can be recycled. A business can also use safe materials in design and manufacture, purchase green products from suppliers, practice waste and water management, use renewable energy sources, use digital technology instead of hard copies, and encourage carpooling.

Philanthropy: Philanthropic social responsibility is all about a company caring about the world in which it exists and striving to improve that world for future generations. It involves making an effort to benefit society. Corporate philanthropy ranges in size and scope, and can include everything from donating money to charities, supporting community volunteerism, sponsoring local events, establishing and funding educational programs, supporting a community's economic growth or funding worthy social causes. It can be undertaken at a local, national or international level. Businesses can also aid in the prevention of harmful activities by supporting groups that advocate for ethical behaviours such as animal rights welfare, coalitions against domestic violence or child abuse, etc.

Ethical practices: Leaders want their companies to be profitable, but this should be done only within the confines of sound legal and ethical precepts. Ethical leaders function within both the **letter and the "spirit' of the law**. They are sensitive to the fact that their everyday business decisions may have deleterious effects on others. The financial crisis of 2007–08 revealed there is a higher need for ethical leaders and transparency in business processes. Business should seek to enhance employee well-being and better working conditions.

Employees locally or internationally should be treated fairly and paid equally. It also includes minimizing the use of child labour as well as refusing to do business with oppressive countries and engaging in fair trade practices. It also involves ethical marketing practices such as not trying to manipulate or falsely advertise to potential customers. **Ethical practices** seeks to make sure that all stakeholders receive fair treatment. There is evidence that the ethical conduct of companies exerts a growing influence on the purchasing decisions of customers. In a recent survey by Environics International, more than one in five consumers reported having either rewarded or punished companies based on their perceived social performance.

Stewart Parnell, former chief officer of Peanut Corporation of America, was sentenced to 28 years in prison for his role in a salmonella outbreak that killed nine people and sickened more than 700 others. He was knowingly selling food that was making people sick. He was also accused of ignoring unsanitary conditions at the plant and fabricating reports on safety tests. The Justice Department described Stewart Parnell's sentence as the largest in a food safety case. The sentences imposed on all those involved were the harshest ever imposed in connection with an outbreak of foodborne illness. The contamination at the plant led to one of the largest food recalls in U.S. history and forced the company into liquidation. According to experts quoted by the Times, this is the first time US food producers have stood trial on criminal charges in a food-poisoning case. Parnell was never charged with killing or sickening anyone, just with **"conspiring to defraud"** customers.

CSR is playing a central role in helping corporations to be seen as leaders. Astute corporations are allocating increasing

internal resources to CSR investments that feature clear objectives and deliver measurable social outcomes.

"No one will thank you for taking care of the present if you have neglected the future." —Joel A. Barke

CSR is already influencing how employees, customers, and stakeholders are deciding whom they'd prefer to follow.

Three steps to get socially involved:

- ⮑ **Pick a current issue.** Declare a clear goal, and mobilize your resources. Make sure is something you easily sustain. Be accountable. You must implement your program strategically. Just giving a donation is not enough. One of my previous employers held a yearly walk against breast cancer fundraiser. This would take a lot time to plan and organize hence, it was done yearly. On the other hand they would give donations to the cancer society on a quarterly basis.

- ⮑ **Make your approach employee-centric.** Get employees involved. Be a catalyst but let them champion it. For example, schedule initiatives where employees can work with the community as a group such as donating time at a local shelter, or volunteering for a cause that is important to your employees. Let them choose, let them lead and support them. One of the greatest benefits of promoting social responsibility is the positive environment it encourages for employees.

- ⮑ **Incorporate social responsibility into your business model.** CSR should be managed just as any other business activity, and thus it should be integrated into the daily operations. Make it part of your culture. Most

importantly, it must be based on a genuine concern for people and the community. A poor strategy will cause people to become cynical and distrustful of your company. Show you genuinely care and want to make a positive impact. A dedication to these initiatives goes a long way, both for the cause and their reputation.

It is also important to track and share your performance. Show employees the results of their involvement as this would give them a sense of fulfilment and solidify future commitment. One of the greatest benefits of an engaged culture in social responsibility is that it improves employee morale.

While many companies now practice some form of social responsibility, some are making it a core of their operations: Altered Seasons – Kelly Reddington founded his eco-friendly candle company Altered Seasons in 2003 at age 14 with the help of his mother. When he assumed ownership of the company, he shifted it to a one-for-one model to do more for the community. For every candle sold, Altered Seasons provides a meal to an American in need through Feeding America.

Often, it not only benefits the business alone, but its employees, customers, community, and the society.

5 BENEFITS OF CORPORATE SOCIAL RESPONSIBILITY:

1 **Brand Differentiation**: Branding your business as 'socially responsible' differentiates you from your competitors. Being socially responsible creates a positive image for your brand.

Reputations that take long to build can be destroyed in hours from environment incidents or corruption scandals.

2 **Retention of staff:** A survey conducted on "Net Impact" found that more than half of workers wish to be a part of a company where they can make an impact. Socially responsible companies report increased employee commitment, performance and job satisfaction.

3 **Customer loyalty:** In an era when awareness among consumers is at an all-time rise, finding the cheapest price is no longer what always matters most to consumers. **Customers are attracted to socially responsible companies** and prefer to support a business that does good for the community. According to Edelman's 2010 Goodpurpose Study, 67% of consumers say they are more likely to buy products and services from a company if they know it supports good causes, up more than 11% from the year before.

4 **Reduction in business costs:** Environmental initiatives such as recycling and waste management can increase in-house efficiency and in so doing cut costs.

5 **Personal and professional growth:** It can help employees develop their leadership and project management skills. It also makes one a better human being, more conscious of the environment and society.

Campbell's Canada's Nourish is a not-for-profit product that specifically targets the growing problem of hunger. This nutritious meal in a can, developed by socially conscious Campbell's staffers, is only distributed to food banks, not directly to consumers. According to Campbell's: "We have a responsibility because of who we are and what we do to take a

lead role in alleviating hunger." Campbell's expected outcome for the initiative was to raise awareness for hunger while at the same time setting an example for other food companies to follow, says Philip Donne, the president of Campbell's Canada. "If we get even one company introducing their Nourish, we will have been successful."

A company's "*social responsibility*" quotient can make a difference to its bottom line. Corporate *social responsibility* is imperative as most customers consider how businesses deal with their environment. Undertaking socially responsible initiatives is truly a win-win situation. It can reduce business risk, improve reputation, and drive market opportunities.

Great leaders don't only focus on the organization and their employees but also the society as a whole. They look at the overall big picture. They are concerned about the future and how their decisions will impact it. **Leaders are responsible for fulfilling their civic duty; the actions of an individual must benefit the whole of society.** They are prepared to do something because it is the right thing to do. It is the leader's responsibility to chart a course in social responsibility, it starts

at the top and will trickle down to the followers. In this way, there will be a balance between business growth and the welfare of society and the environment. Remember CSR is a journey well worth taking. Not only will your company appeal to socially conscious employees and customers, but you'll also make a real difference in the world. It is our duty to help others. Will you fulfil your duty today? As Mahatma Gandhi so emphatically stated, "Be the change you wish to see in the world."

"We know only too well that what we are doing is nothing more than a drop in the ocean. But if the drop were not there, the ocean would be missing something."—Mother Teresa

Conclusion

Leadership in the twenty-first century requires more than ever: vision, communication, integrity, creativity, inspiration, change and a greater focus on social responsibility.

Vision that paints a clear picture of the future and gives hope.

Communication which ensures everyone is onboard and progressing in the same direction.

Integrity which creates trust thereby extending your influence.

Creativity that takes you over the edge to get the results you want.

Inspiration that will motivate you and your team to achieve the impossible.

Change that will propel your organization ahead of the competition.

Social responsibility which shows you are committed to making a meaningful contribution.

The "**Edge of Leadership**" is focused on holistic or sustainable leadership. This is leadership that will stand the test of time and which is for the overall good of the leader, followers, and society.

References

Sources: https://en.wikipedia.org

Photos:

- ↺ http://www.kozzi.com
- ↺ http://www.dreamstime.com
- ↺ http://www.123rf.com

Top Contributor: **Sergey Nivens**

Epilogue

We have come to the end of this book. Thank you for staying with it. I hope you have known at all times that the author has your best interests in mind. **The Edge of Leadership: A Leader's Handbook for Success** applies theories in a realistic setting. It combines wisdom from the ages with the author's insights, thus giving a winning formula for success.

May you apply these principles outlined in this book to excel in your leadership role. It has worked for many others and can do exactly the same for you.

I wish you the very best in life!

Sincerely,

Brigette